IMAGES

of Modern America

MILWAUKEE
ROCK AND ROLL

IMAGES
of Modern America

MILWAUKEE ROCK AND ROLL

Larry Widen

ARCADIA
PUBLISHING

Published by Arcadia Publishing
Charleston, South Carolina

Printed in the United States of America

Library of Congress Control Number: 2014945557

For all general information, please contact Arcadia Publishing:
Telephone 843-853-2070
Fax 843-853-0044
E-mail sales@arcadiapublishing.com
For customer service and orders:
Toll-Free 1-888-313-2665

Visit us on the Internet at www.arcadiapublishing.com

CONTENTS

FOREWORD

When someone says, "Milwaukee," a million really cool things race through my brain, like the lights on a pinball machine: *Milwaukee!* 'Twas years earlier, way before Cheap Trick existed. I loved seeing Eddie Mathews, Del Crandall, and Warren Spahn play at County Stadium. I even had a baseball card signed by Hank Aaron. Anybody remember Dime Beer Night? I only had three bucks on me that time, so . . . well, you do the math.

From the beginning, Milwaukee has been a great city for rock and roll. I could have gone to Woodstock in 1969, but I didn't because right around the same time Jeff Beck, Blind Faith, and a bunch of other great bands were playing a weekend festival at Wisconsin State Fair Park. The manager of former Mountain guitarist Leslie West had some Milwaukee connections, so Leslie was always in town, playing a club like Mother's or Fantasy's. Don't get me started on Summerfest. No city on the planet has an annual gig like that one! I loved the Plasmatics at the Palms, with Wendy O. Williams smashing stuff and cutting televisions in half with a chainsaw. And they say Rick is the one with the crazy onstage antics.

Milwaukee became a home away from home for Cheap Trick way back when. I'll never forget that crappy stage and the 10-foot-tall, bang-your-head-on-it ceiling at Hanna's and pushing through the crowd at the end of a set to get a beer at the bar. The gigs have gotten better since then, but two things haven't changed: the love I have for Milwaukee, and the love that's been returned too many times to count. Hanna's is gone, and the stadium is history, but Cheap Trick and this town are gonna rock together for a long, long time to come.

—Rick Nielsen

ACKNOWLEDGMENTS

For their assistance in preparing this book, thanks go to Gregg Allman, Clayborn Benson and the Wisconsin Black Historical Society, John Bond, Clancy Carroll, Alice Cooper, David "Honeyboy" Edwards, Evergreen Park, milwaukeerockposters.com, David Glazer, Buddy Guy, *MATC Times*, Guy Hoffman, Joan Jett, B.B. King, Jill Kossoris, Highland Gardens Hotel, Sam Lay, the Oriental Theatre, the University of Wisconsin–Milwaukee Libraries, the *Milwaukee Journal Sentinel*, the Milwaukee Public Library, Richard Penniman, Joe Pride, Mary Skanavis, Alexandra Topping, Johnny Van Zant, Ken Weinstein and Big Hassle Media, Bob Weir, Johnny Winter, and Mike Wozniak.

Thanks to photographers Chuck Barth, Bobbin Beam, Chris Corsmeier, Jeff Dobbs, Dennis Felber, Al Gartzke, Dave Gilo, Hank Grebe, David LaHaye, Charlie McCarthy, Gary Myers, Leonard Sadorf, Jim Schnepf, George Taylor, Tim Townsend, Leonard Widen, and Rich Zimmermann. Their images may not be reproduced in any format without permission.

Some other folks to whom I am grateful:

My mom, Marlene Widen, who cooked dinner for Johnny Winter and his band. They forgot to return her dishes when they left town, but hey, that's rock and roll.

My dad, Len Widen, for taking me to see Johnny Cash and Carl Perkins at the state fair in 1969.

Len Sadorf, who whispered questions to ask Little Richard during the interview. And Richard, thank you for the big hug you gave my daughter—she'll never forget that.

Ted Morris for the video of Honeyboy Edwards singing "Big Fat Mama." Everybody needs a wingman like that. When John Lee Hooker shook his hand in 1985, Ted refused to wash it for a week.

Rick Nielsen, thank you for your foreword. I wish we could have gotten the stuff about Huntz Hall and the Three Stooges in here, but we had to focus on Milwaukee and rock and roll.

Nick Topping, who saw the book before anyone else. When Pete Seeger was one of the most hated men in America, Nick paired him with Sonny Terry, a black bluesman who could barely get in the front door. We love you for that.

To Tom Gould, Marjorie Burke, and Mary Anne Gross, thank you for teaching us how to write.

And for Dave Gilo: remember, amigo, heavy is the head that wears the crown.

Chapter headings were inspired by the following songs: "The Blues Had a Baby (and They Named It Rock and Roll)," written by McKinley Morganfield and Brownie McGhee. © 1977 by Watertoons Music, primary recording by Muddy Waters with Johnny Winter, James Cotton, Bob Margolin, and Pinetop Perkins; "Great Balls of Fire," written by Otis Blackwell and Jack Hammer. © 1957 by Carlin Music Corporation, primary recording by Jerry Lee Lewis; "It's Only Rock and Roll (but I Like It)," written by Mick Jagger and Keith Richards, © 1974 by Promopub, primary recording by the Rolling Stones; "Jumpin' Jack Flash," written by Mick Jagger and Keith Richards, © 1968 by Gideon Music Inc., primary recording by the Rolling Stones; "Born under a Bad Sign," written by Booker T. Jones and William Bell. © 1967 by East/Memphis Music, primary recording by Albert King.

INTRODUCTION

In this unique musical history of Milwaukee, you are going to encounter folk singers, heavy-metal icons, balladeers, big-band cats, top-40 pop stars, and duckwalking, keyboard-pounding, guitar-strumming heroes of rock and roll. The only thing that all of them have in common is where their particular style of music originated. The rock music that has been a part of our collective consciousness since the mid-1950s came from the countless African men and women who were transported to this country in chains and put to work in the farmlands of Virginia, Georgia, the Carolinas, Louisiana, Alabama, and Mississippi. Without them, there would be no Mick Jagger, Eric Clapton, or Ozzy Osbourne; no Bob Dylan, Arlo Guthrie, or Jerry Garcia; and no Johnny Cash, Jerry Lee Lewis, or Elvis Presley either. There would be some form of popular music, of course, but it would not sound anything like what we have embraced and enjoyed all these years. The history of rock and roll in Milwaukee, or anywhere for that matter, began in the dank hold of one of the many slave ships that sailed to the New World laden with illicit human cargo. The pain and agony these people endured poured out of them in words, music, and rhythms that came to be called "the blues."

Robert Johnson rests quietly beneath an expansive pecan tree in the rear of a Greenwood, Mississippi, church graveyard. Nearly 80 years after his death, the singer's granite marker is still decorated with coins, guitar picks, and other offerings from those who have made the pilgrimage to pay their respects. The legend of Robert Johnson selling his soul to the Devil in exchange for unlimited musical talent is synonymous with the blues. For decades, blues fans and musicologists alike have searched for the location at which the unholy bargain was struck. Many believe the mythic ground is the junction of Mississippi State Highways 61 and 49, just outside of Clarksdale. Others maintain the crossroads exists only in voodoo, the centuries-old superstitious hybrid of African and Catholic religions mentioned in so many blues songs.

Mississippi has spawned more blues singers than the other 49 states combined, primarily because the land is so fertile for agriculture. Greenwood, in the heart of the Mississippi River Delta, still produces a staggering 20 percent of the world's cotton crop each year. For several hundred years, African American laborers toiled in these fields, first as slaves and then as sharecropping freedmen. B.B. King, George "Buddy" Guy, Chester Arthur "Howlin' Wolf" Burnett, and a number of other musicians born in the early part of the 20th century worked alongside family members on plantations for less than a dollar a day. To make the time in the sun a bit more palatable, workers sang songs, or "field hollers," to each other. The music of the fields was adopted by black churches that were founded in the decades following the Civil War. In the 1920s and 1930s, musicians used their voices and acoustic guitars to bring these primitive rhythms out of the fields and churches and onto Mississippi street corners. From there, it was only a short time before the blues went north on Highway 61 to Beale Street in Memphis, Tennessee.

Memphis was the largest regional commercial center in the 1930s and had a number of radio stations and nightclubs where African American musicians could work. By 1950, a 15-year-old Elvis Presley was one of the few whites who spent time on Beale. Presley loved the black music scene and defied his parents' orders not to wear the baggy suits and loud shirts worn by his heroes.

The former Memphis Recording Service and Sun Records studio, located at 706 Union Avenue, is sacred ground to music fans. Although only as large as an average living room, an astonishing number of musicians recorded at Sun, including Howlin' Wolf, James "Little Milton" Campbell Jr., Johnny Cash, Jerry Lee Lewis, Carl Perkins, and Roy Orbison. On July 5, 1954, Presley, along with Bill Black and Scotty Moore, recorded "That's All Right, Mama," the groundbreaking single that combined blues, gospel, and country. The building, still open for tours, is virtually intact with the original floors, ceilings, and recording equipment used by these artists. Memphis is also home to the Gibson guitar factory, where visitors can see a semi-hollow-body electric guitar being made by hand. In the plant at 145 George W Lee Avenue, the company produces between 35 and 40 of its ES-series guitars each day. Retailing for $4,000 each, the ES guitar is favored by performers like B.B. King.

Renowned musicologist Alan Lomax, working under the auspices of the Library of Congress, spent much of the 1940s in the Delta and surrounding areas recording African American blues singers in an effort to preserve their sound for posterity. Many of the musicians that Lomax discovered began working in Memphis or Chicago and went on to have significant careers. And while some are interred in Northern cemeteries, many others were returned to the Delta to be buried. They now lay in quiet, hard-to-find churchyards several miles from the highway. Charley Patton is buried in Holly Ridge, John Lee Curtis "Sonny Boy" Williamson is in Tutwiler, and Elmore James is in Ebenezer. Lizzie Douglas, better known as Blues singer "Memphis Minnie," rests in the tiny town of Walls, where a visitor to her gravesite can see nothing but cotton fields in all directions. "Mississippi" John Hurt is hidden in a long-lost cemetery within a forested area of Avalon.

All of these gravesites are less than a 30-minute drive from Clarksdale, the last Delta city before Memphis. Clarksdale's blues legacy goes far beyond the fact that it might contain the crossroads where Robert Johnson met the Devil. John Lee Hooker was born just outside the town, and W.C. Handy, the "Father of the Blues," lived there. The Riverside Hotel, located on Sunflower Avenue, was the African American hospital until 1944. Singer Bessie Smith died there in 1937, Ike Turner wrote "Rocket 88" in the lobby in 1948, and guitarist Robert Nighthawk left a suitcase in his room in 1952. (That suitcase is still there, by the way. The owner of the Sunflower prefers to keep it unopened just in case Nighthawk ever decides to return).

South of Clarksdale, on Highway 49, is Greenwood, where Robert Johnson died. The handsome singer always had an eye for the ladies, and it caught up with him one August night in 1938. Johnson was performing at a roadhouse outside of town when a jealous husband slipped strychnine into his bottle of whiskey. Johnson fell ill and was taken to a house in Greenwood's Baptist Town, a poor African American neighborhood across the railroad tracks. Johnson died an agonizing death several days later, but not before making a deathbed reconciliation with the Lord. Whether the Devil ever collected Johnson's soul still makes for lively discussion among fans. As for the house, it has been demolished, but a placard at the intersection of Young and Pelican Streets marks the location.

Farther down Highway 61, near the Louisiana border, is the tiny town of Gillsburg, Mississippi. On October 20, 1977, the Lynyrd Skynyrd blues-rock band was flying from Greenville to Baton Rouge, Louisiana, when their plane began experiencing mechanical difficulties. The plane crashed in the woods on land owned by farmer Johnny Mote, instantly killing singer Ronnie Van Zant, guitarist Steve Gaines, singer Cassie Gaines, band manager Dean Kilpatrick, and both pilots. Eyewitnesses said the aircraft was torn apart the second it hit the tall trees. The exact site of the crash, deep in a heavily forested area off P.P. Wilson Road, is virtually impossible to get to today without a four-wheel drive vehicle and a knowledgeable guide. John Bond, a retired dairy farmer who lives nearby, was one of the first people on the scene of the crash that October night. Bond and some of his neighbors pulled the injured passengers out of the wreckage and through the woods to the highway. When ambulances failed to materialize, the men used their pickup trucks to transport crash victims to the hospital in McComb, more than 10 miles away. By their own admission, Bond and his wife, Inez, prefer listening to church music and have never heard a Lynyrd

Skynyrd record, but they are quick to invite a visitor into their home and talk about the events of that October evening, even pulling out the old newspapers with the accounts of the crash. Bond will drop everything to take a fan out to the crash site, which is significant since Mote recently sold the land to an Asian businessman that has no interest in its history. Because there's no commemorative marker or sign to identify the significance of the site, the actual location will be lost to visitors once someone like Bond is unable to take them there.

The blues literally came out of the Mississippi dirt, and many originators of this unique American art form have since gone back into that ground. While they were alive, their music lit a fire within others who adopted it as their own before passing it on. Most notably, American blues resonated inside the "war babies," British teenagers born during Hitler's Blitzkrieg. Lonnie Donegan formed a skiffle band based on a form of jazz-boogie played at African American rent parties in the 1920s and 1930s. Richard Starkey, later to call himself Ringo Starr, loved Sam "Lightnin' " Hopkins so much that he wrote to factories in Texas, asking for employment. Among John Lennon's early influences were the penitentiary blues songs of Huddie Ledbetter, better known as "Lead Belly." Keith Richards and Brian Jones listened to Jimmy Reed and Robert Johnson until they were able to play along note for note. Robert Plant and Jimmy Page parsed the music of Willie Dixon, Booker T. Washington "Bukka" White, and "Blind" Willie Johnson. At the age of 15, George Harrison joined the Les Stewart Quartet, a Liverpool group that covered the music of "Big Bill" Broonzy, Josh White, Muddy Waters, and Sonny Terry and Walter "Brownie" McGhee. These are but a few examples of how American blues affected budding musicians on another continent. At the same time the English boys were discovering this music, the records of Little Richard, Carl Perkins, Johnny Cash, and Elvis Presley, steeped in that same brew, were giving joy to hundreds of bands hungry for new sounds from the New World. In time, the best of those groups would bring American blues back to the United States. It was louder, faster, and more technically accomplished, but at the end of the day, it all came out of the same Delta cotton field.

Elvis Presley was born in Tupelo, Mississippi, in 1935. The postwar job market drew his family to Memphis, where Presley fell in love with the music coming from black nightclubs on Beale Street. When a teacher told him he had no singing ability whatsoever, he got out his guitar and performed "Keep Them Cold Icy Fingers Off Me," much to the teacher's displeasure. In 1955, Sam Phillips, owner of Sun Records, liked the gospel-blues-country fusion that Presley projected, and together they began recording the songs that changed modern musical tastes forever. Presley died in 1977 at the age of 42 and is buried at Graceland, his former Memphis estate.

Thankfully, this massive American legacy lives on within the work of the Beatles, Led Zeppelin, the Rolling Stones, Black Sabbath, Johnny Winter, Deep Purple, Jimi Hendrix, the Doors, and countless other bands. But, even more importantly, the music still resounds joyously along the unpaved roads, forgotten graveyards, and acres of cotton fields that sit beneath the unrelenting Mississippi sun. It's all there for music lovers to experience—they just have to know where to look.

The roots of rock and roll in Milwaukee began in the post–World War II nightclubs that opened in the African American neighborhood informally known as "Bronzeville." Performers such as Muddy Waters, B.B. King, Billie Holiday, and even Duke Ellington performed here before it became fashionable to play in the white jazz clubs downtown. By the mid-1950s, black performers were idolized by white teenagers, which prompted venues such as Devine's Million Dollar Ballroom and the Riverside Theater to begin booking these acts. For the most part, segregation disappeared by the early 1960s, and bands of all color played at the city's premier venues. It is important to track this simply because without Muddy Waters and his contemporaries there are no Rolling Stones or Led Zeppelin. Now, go and have fun reading about the history of rock and roll in Milwaukee!

One

"The Blues Had a Baby (and They Called It Rock and Roll)"

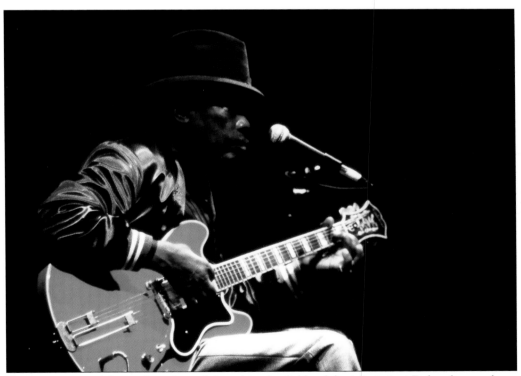

For generations, African Americans labored in the fields of the Mississippi Delta, first as slaves and then as sharecropping freedmen. John Lee Hooker (pictured in 1983 at the Summerfest grounds), B.B. King, Buddy Guy, Howlin' Wolf and countless others worked alongside family members on farms for less than a dollar a day. The songs and "field hollers" that helped pass the time originated aboard slave ships that transported Africans to the New World. The music spread from the cotton fields to black churches established in the decades following the Civil War. It was also performed by street musicians in every Delta town. (Photograph by author.)

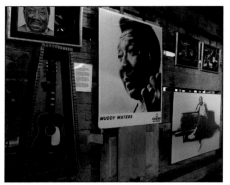
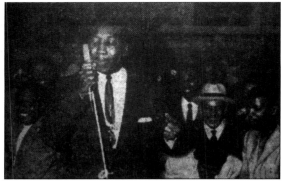

The remains of Muddy Waters's home have been turned into a museum in Clarksdale, Mississippi. In a rare image from a Milwaukee African American newspaper, Waters is captured during a 1956 show at the Wonderland. British teenagers like John Lennon, Eric Clapton, Keith Richards, Mick Jagger, Rod Stewart, and Jimmy Page were drawing inspiration from Waters and other American blues artists during this time. A decade later, the Beatles, the Rolling Stones, Cream, the Faces, and Led Zeppelin would perform their role models' music to appreciative mainstream audiences. (At left, photograph by author; at right, author's collection.)

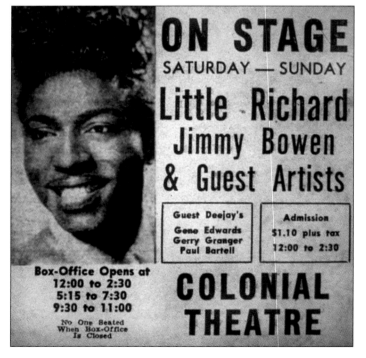

Little Richard, born Richard Penniman, quit his job as a dishwasher in the Macon, Georgia, Greyhound station in 1953 and formed a vocal group called the Tempo Toppers. Drawing heavily on the gospel music he sang as a child, Penniman incorporated the driving piano style of Fats Domino to come up with smash-hit singles like "Tutti Frutti." During a period of racial tension in the United States, Penniman's music attracted black and white kids alike. One of his first Milwaukee performances was on April 13, 1957, at the Colonial movie theater on Fifteenth and Vliet Streets. (Author's collection.)

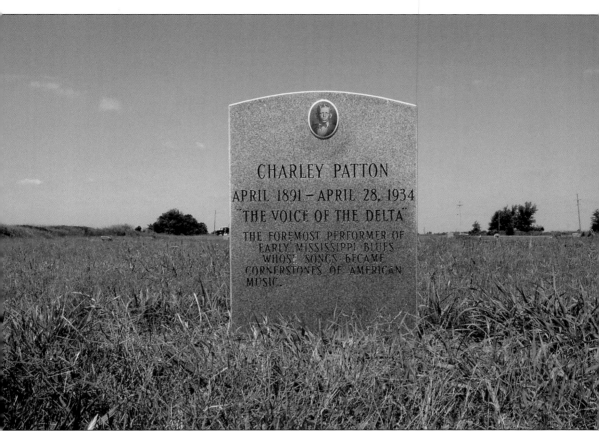

Over 60 African American musicians, such as Charlie Patton, "Blind" Lemon Jefferson, Tommy Johnson, Nehemiah "Skip" James, Sam Chatmon, Son House, Arthur "Blind" Blake, and Louis Armstrong, traveled by train from Mississippi and Louisiana to record their blues, spirituals, and even sermons in a crudely built studio inside an old chair factory in Grafton, Wisconsin. More than 1,600 recording were made between 1929 and 1932, at which time the studio ceased operation. (Photograph by author.)

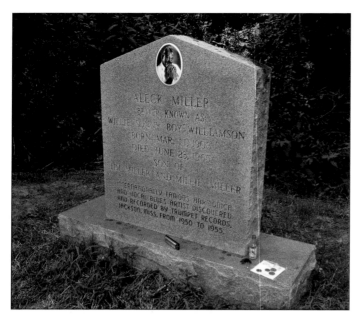

In the early 1950s, legendary blues harmonica player Sonny Boy Williamson recorded "Eyesight to the Blind" and "Nine Below Zero" in Mississippi before moving north. He lived in Milwaukee and traveled to Chicago for sessions with Chess Records. While in Milwaukee, Williamson wrote his classic "One Way Out," later made famous by the Allman Brothers Band. The Skunks, a local band made up of Jack Tappy, Tony Kolp, Larry Lynne, and Ted Peplinski, recorded "Fanny Mae" with Williamson in 1964. (Photograph by author.)

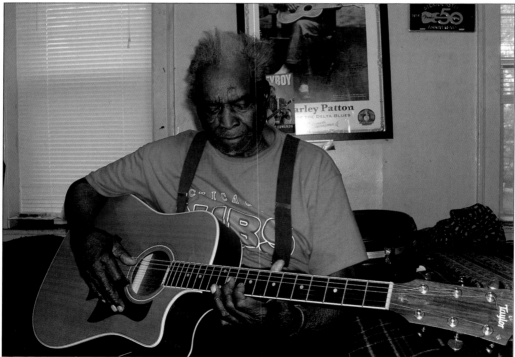

Pictured is Delta blues legend David "Honeyboy" Edwards at his apartment in Chicago. He performed at the Times Cinema on Vliet Street in 2007 and again in 2009. Edwards traveled all over Mississippi with bluesmen Robert Johnson, Charley Patton, and Johnny Shines as a youth. He was arrested in Milwaukee in 1947 when police raided the club where he was playing with Marion "Little Walter" Jacobs. Honeyboy Edwards died in 2011 at the age of 96. (Photograph by author.) WI. Conservatory of Music 1988

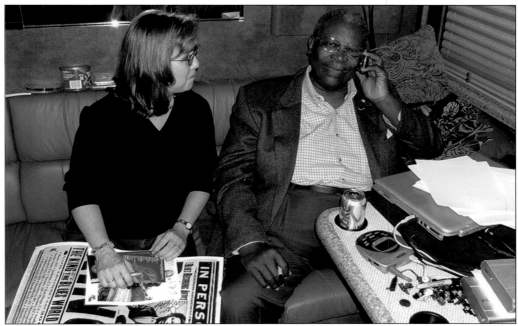

Riley King, better known as B.B. King, was born in Itta Bena, a tiny town in Mississippi's Delta region. Bukka White showed him some guitar chords, and in 1946 King headed north to Memphis. He spun records for a radio station and sang under the name "Blues Boy." His first hit, "3 O'Clock Blues," boosted King into the national spotlight. He has played at Summerfest, the Riverside, County Stadium, and the Auditorium. At age 88, B.B. King still performs 100 shows a year. Judi Widen sits with King in the lounge of his deluxe touring bus after a show at the Northern Lights Theater. (Photograph by author.) *EAU CLAIRE/ 1971 Elsewhere?*

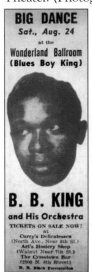

The Masonic Hall at Twelfth Street and North Avenue housed a popular stage called the Ron-De-Voo Ballroom, later the Wonderland. Louis Armstrong, Muddy Waters, B.B. King, Little Walter, and "Magic Sam" Maghett are a few of the influential musicians who played here. (At left, author's collection; at right, photograph by author.)

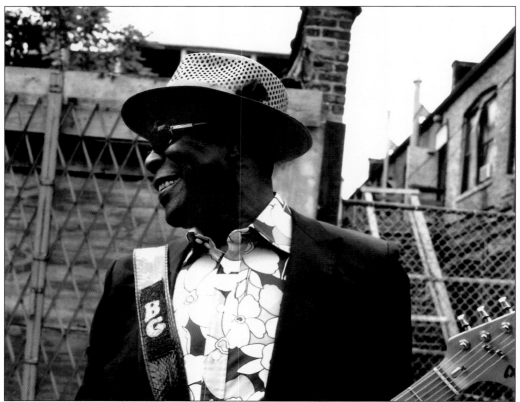

Buddy Guy began working for Chess Records in 1957 as a session player for Muddy Waters, Little Walter, Howlin' Wolf, and Sonny Boy Williamson. He was an integral part of Chicago's West Side Sound with Magic Sam, Otis Rush, and Amos "Junior Wells" Blakemore. Eric Clapton, Jimi Hendrix, and Stevie Ray Vaughan all cited Guy as a major influence on their work. Since the 1980s, Buddy Guy has appeared in Milwaukee at least once each year. (Author's collection.)

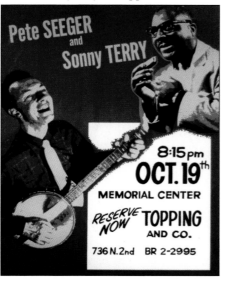

Pete Seeger passed away on January 27, 2014, at the age of 94. Along with Woody Guthrie, Seeger used music to show support for the workingman. In 1941, Seeger and Guthrie performed a concert to benefit the striking workers at Allis-Chalmers. Seeger did another for Patrick Cudahy employees in 1978. Promoter Nick Topping brought Seeger to town in 1958 for a show with blues singers Sonny Terry and Josh White. Topping also brought him to the Oriental Theatre in 1965. Seeger played the Performing Arts Center in 1972 and several times at Summerfest, most notably on July 3, 1982, when he shared the stage with Woody Guthrie's son Arlo. Seeger was inducted into the Rock and Roll Hall of Fame in 1996. His musical legacy includes the songs "Where Have All the Flowers Gone," "Turn! Turn! Turn!" and "If I Had A Hammer." (Courtesy of Alexandra Topping.)

SAW SEEGER AND A. GUTHRIE @ Summerfest in 1977 and 1980

Legendary blues singer Howlin' Wolf (right) performed at the Milwaukee Blues Bonanza in 1973 at Wisconsin State Fair Park. Also on the bill were Albert King and the Siegel-Schwall Band. (Courtesy of the Milwaukee Public Library.)

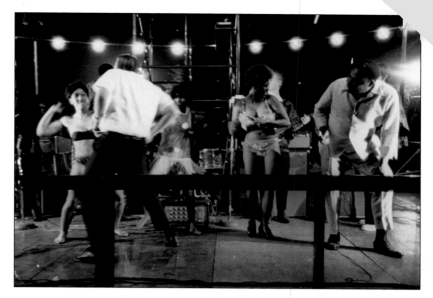

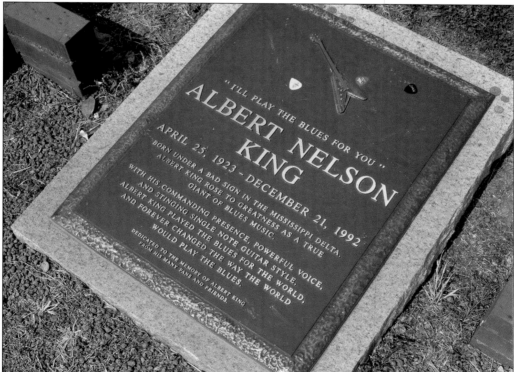

"I'LL PLAY THE BLUES FOR YOU"
ALBERT NELSON KING
APRIL 25, 1923 - DECEMBER 21, 1992
BORN UNDER A BAD SIGN IN THE MISSISSIPPI DELTA,
ALBERT KING ROSE TO GREATNESS AS A TRUE
GIANT OF BLUES MUSIC.
WITH HIS COMMANDING PRESENCE, POWERFUL VOICE,
AND STINGING SINGLE NOTE GUITAR STYLE,
ALBERT KING PLAYED THE BLUES FOR THE WORLD,
AND FOREVER CHANGED THE WAY THE WORLD
WOULD PLAY THE BLUES.
DEDICATED TO THE MEMORY OF ALBERT KING
FROM HIS MANY FANS AND FRIENDS.

Eric Clapton and Stevie Ray Vaughan named Albert King as a major influence on their playing style. King played the Scene in 1970 and Zak's in 1975. He also performed at Teddy's and the Performing Arts Center. His final Milwaukee appearance was in 1991 at Summerfest. The *Milwaukee Journal* noted, "King had the blues about feedback, too much bass and all the hot lights. He paced the stage and shot dirty looks at the sound man. The crowd gave King a hand when he finally smiled more than 20 minutes into the show." He died the following year at age 69. (Photograph by author.)

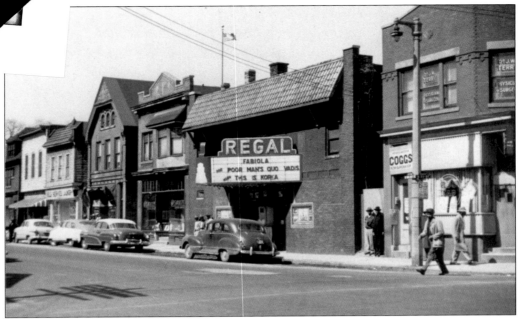

The intersection of Seventh and Walnut Streets was the heart of Milwaukee's Bronzeville district in the 1950s. Nightclubs, theaters, barbershops, record stores, grocers, and restaurants lined both sides of Walnut all the way from Third Street to Twelfth Street. Local politician Isaac "Ike" Coggs's popular 700 Tap can be seen at right. In the late 1960s, the majority of the district was razed to make room for the construction of Interstate 43 and other arterial road expansions. (Courtesy of the Wisconsin Black Historical Society.)

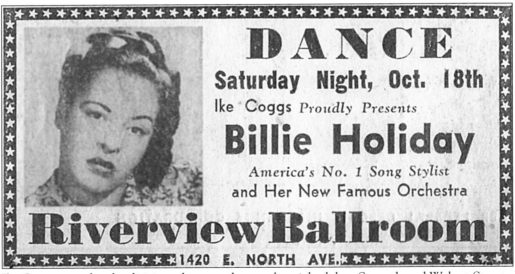

Ike Coggs was a local politician who owned a popular nightclub at Seventh and Walnut Streets. Coggs also promoted music shows at the Riverside Ballroom, a former roller-skating rink located on the Milwaukee River at Humboldt and North Avenues. (Author's collection.)

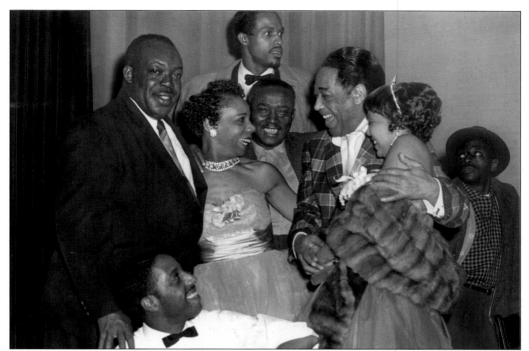

In 1957, world-famous bandleader Duke Ellington (foreground, second from right) arrived in Milwaukee to perform at the Flame Club with local favorite Loretta Whyte (center). Whyte's father, James "Derby" Thomas (behind Whyte), was a Bronzeville promoter who staged shows at the Wonderland Ballroom on North Avenue. Her son Archie Whyte is kneeling in the foreground. (Courtesy of the Wisconsin Black Historical Society.)

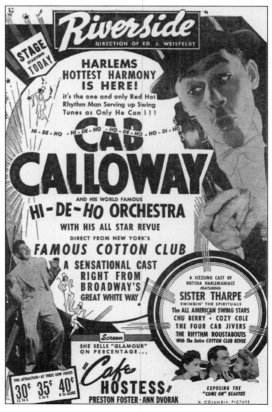

Jazz singer and bandleader Cab Calloway began performing at the Cotton Club in Harlem in the 1930s. He was a frequent attraction at the Palace and Riverside Theaters for decades after. In 1980, a whole new generation was exposed to Calloway's music when he appeared in the film *The Blues Brothers*. He is pictured in a 1988 appearance at Uihlein Hall. Calloway continued to perform until his death in 1994 at age 86. (Author's collection.)

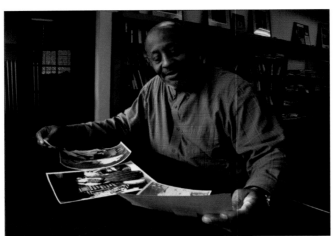

Clayborn Benson, the executive director of the Wisconsin Black Historical Society, reviews a rare collection of photographs depicting some of the musicians who played at Milwaukee's African American nightclubs. The society's archives include photographs of Dinah Washington and Lionel Hampton at the Riverside Ballroom, Duke Ellington at the Flame, and the Satin Doll on stage at her lounge. (Photograph by author.)

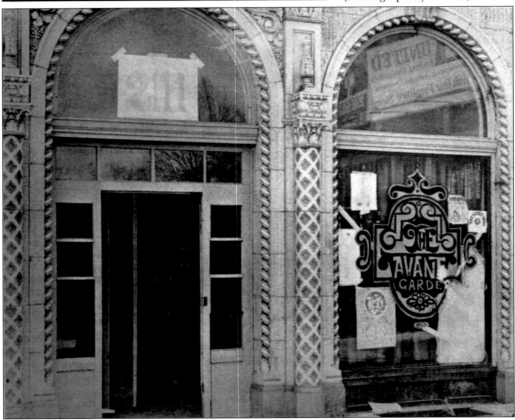

The Avant Garde on Prospect Avenue offered an eclectic mix of local and nationally known musicians. Rev. Gary Davis was an influence on Bob Dylan, the Grateful Dead, and Jackson Browne. His gloomy spiritual, "You Got to Move," was performed by the Rolling Stones at County Stadium in 1975. Skip James, who recorded in Grafton at Paramount Studios, was revered by Eric Clapton, Deep Purple, and Derek Trucks. Magic Sam was at the forefront of Chicago's West Side Sound movement. A recording of his show at the Avant Garde was released in 2013. (Author's collection.)

Blues-rock guitarist Jimi Hendrix was already on his way to becoming a music legend when he appeared at the Scene for a two-night stand in February 1968. The set list for the first show included "Red House," "Foxy Lady," and "Purple Haze." The second show was completely different and featured "Bold as Love," "Sgt. Pepper's Lonely Hearts Club Band," "Stone Free," and a Muddy Waters cover, "Hoochie Coochie Man." Several audio recordings of these shows can be downloaded from the Internet. (Author's collection.)

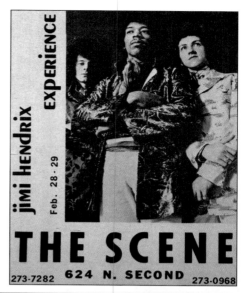

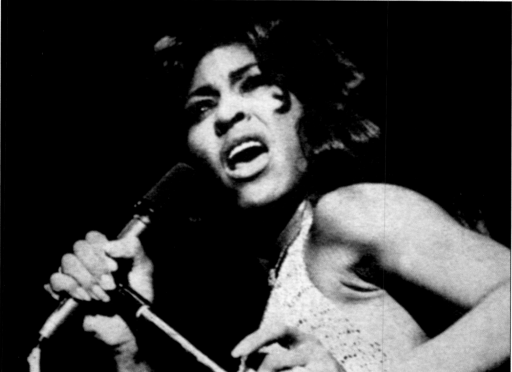

Ike and Tina Turner brought their high-energy show to the Arena on June 25, 1971. The band delivered horn-driven soul renditions of "Come Together," "Proud Mary," "River Deep Mountain High," and "I've Been Lovin' You Too Long." Citing domestic abuse, Tina Turner divorced Ike in 1978 and built a solo career for herself. The Private Dancer Tour brought her to Milwaukee in May 1984. Other area concerts included Alpine Valley in 1985 and 1987, Summerfest in 1997, and the Bradley Center in 2000. Ike Turner died in 2007. (Courtesy of the *UWM Post*.)

Blues guitarist Johnny Winter was heavily influenced by the music of Ray Charles, Muddy Waters, and Sonny Boy Williamson while growing up in Beaumont, Texas. When B.B. King invited the 15-year-old Winter to sit in with the band one night, he had no inkling of the teenager's phenomenal abilities. Winter performed at the Times Cinema in July 2007. He died on July 16, 2014. (Photograph by Tim Townsend.)

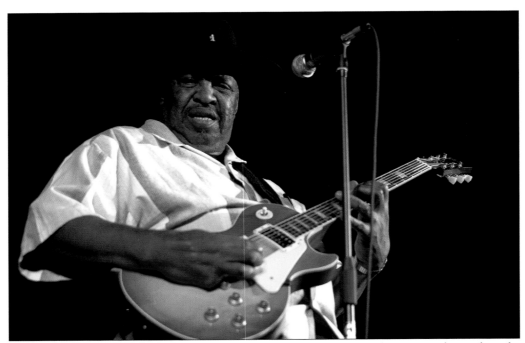

Chicago bluesman Morris Holt, better known as Magic Slim, began his career playing bass for his friend and mentor Magic Sam. In 1970, he formed his own group, the Teardrops. Their first album, "Born under a Bad Sign," released in 1977, was followed by recordings for the Alligator, Rooster Blues, Wolf, and Blind Pig labels. Magic Slim and the Teardrops played the Times Cinema in 2010. He died in 2013 at age 75. (Photograph by David LaHaye.)

Sam Lay is seen during a solo performance at the Times Cinema in 2007. This legendary musician can be heard on dozens of Chess recordings accompanying Howlin' Wolf, Magic Sam, John Lee Hooker, Muddy Waters, Little Walter, and many others. Lay is the drummer on Bob Dylan's album *Highway 61 Revisited*. He has also been a member of the Siegel Schwall Blues Band since 1987. (Photograph by David LaHaye.)

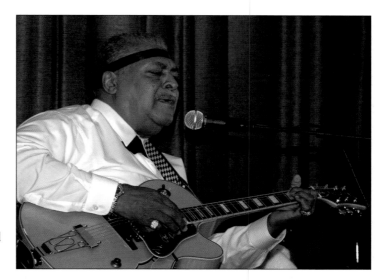

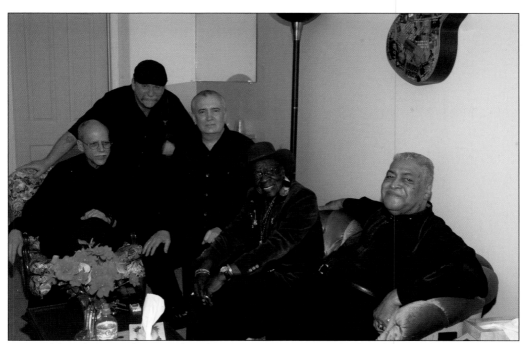

Pictured from left to right are Milwaukee musicians Roger Brotherhood, Jimi Schutte, Jim Liban, and Bob Stroger with Sam Lay backstage after their show at the Times Cinema. In the 1970s, the Sam Lay Blues Band played Summerfest, the Stone Toad, Teddy's, and Zak's. (Photograph by Tim Townsend.)

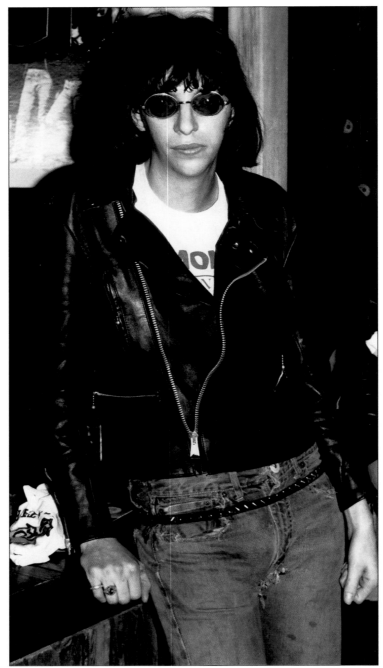

In January 1978, the Ramones did an autograph session at the 1812 Overture record store on Sixtieth Street and Capitol Drive. Singer Joey Ramone agreed to pose for one picture, saying he needed to save his energy for that night's show at the Electric Ballroom. Six months earlier, the band wowed 3,500 fans during a Fourth of July show at Summerfest. The group disbanded in 1996 after nearly 2,300 shows. Joey, guitarist Johnny Ramone, drummer Tommy Ramone, and bassist Dee Dee Ramone have all since passed away. (Photograph by author.)

Two

"You Shake My Nerves and You Rattle My Brain"

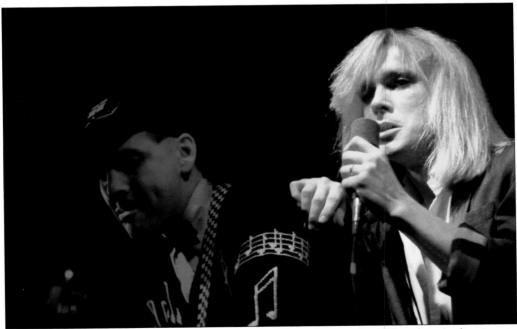

Rick Nielsen (left) and Robin Zander of Cheap Trick perform at the Milwaukee Auditorium in 1980. On any given weekend throughout the 1970s, it wasn't unusual to find them playing clubs such as Hanna's, Stone Toad, He and She, Teddy's, or Sunset Bowl. If they weren't at one of the clubs, the band was at Summerfest or opening for a headliner at the Riverside. If any group deserved to hit the big time, it was Cheap Trick. Their signature sound was forged and perfected in the hot, sweaty bars and clubs of Milwaukee. (Photograph by author.)

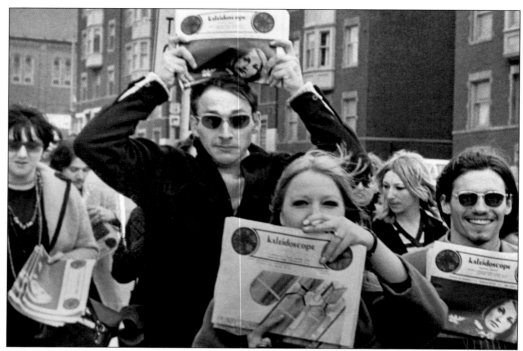

Milwaukee's first important counterculture vehicle was the biweekly newspaper *Kaleidoscope*. The paper, created by writer John Kois, FM disc jockey Bob Reitman, and local musician John Sahli, began publication in the fall of 1967. Typically, a press run of 3,500 papers would be distributed through placement in coffeehouses and bookstores and by college students who sold them on the street. Although *Kaleidoscope* published a comprehensive calendar listing local concerts, it was the sexual or drug-related poetry, essays, and photographs that made it a target for censorship. A loss of advertising revenue contributed to the paper's demise in 1971 after 105 issues. (Courtesy of the Milwaukee Public Library.)

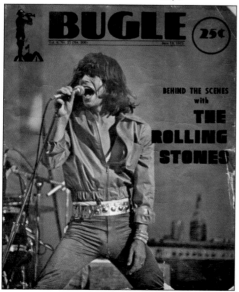

The *Bugle-American* began publication in late 1970 as a less-controversial alternative to *Kaleidoscope*. Still considered an underground publication, the *Bugle* devoted a great deal of space to local musicians, concert announcements and reviews, film essays, poetry, and picture pages from area photographers. The paper's offices were firebombed in 1975. Although the perpetrators were never caught, compelling evidence suggested involvement by a rogue group of Milwaukee police officers. Musicians Leonard Cohen and Bryan Ferry were among those who contributed money to help the *Bugle* recover from the attack. The paper ceased publication in 1978 after 316 issues. (Courtesy of Len Sadorf.)

f 1975 COUNTY STADIUM

The Everly Brothers performed at Pius High School in Wauwatosa in April 1972. Phil (left) and Don Everly first hit the charts in 1957 with "Bye Bye Love" and "Wake Up, Little Susie," "All I Have to Do Is Dream," and "Bird Dog" followed. When the British Invasion changed pop music, the Everlys struggled to stay relevant. With a band that included a young Warren Zevon on keyboards, the brothers attempted a comeback tour, but their relationship fell apart shortly after the Pius concert. Don and Phil did not speak to one another for the next 10 years. (Photograph by Rich Zimmermann.)

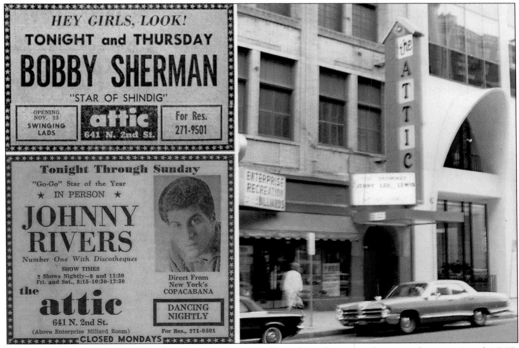

Jerry Lee Lewis was the headliner at the Attic when this photograph was taken in April 1965. The nightclub was located on Second Street just south of Wisconsin Avenue. Acts that performed here included Johnny Rivers, Neil Sedaka, the Platters, Bobby Sherman, Del Shannon, Joey Dee and the Starlighters, Jay and the Americans, Bobby Goldsboro, Chuck Berry, and Gary Puckett and the Union Gap. Count Basie, the Everly Brothers, and Lewis often returned two or three times each year. (Photograph by Gary Myers.)

The Scene opened in 1965 inside the Antlers Hotel at Second Street and Wisconsin Avenue. Prior to becoming a music club, the space was the Swan Theater. The first performer was Chuck Berry. Fans were able to see Cream, Steppenwolf, Frank Zappa, and the Allman Brothers in an intimate setting just before they became arena-sized acts. The Scene was under the management of Benedetta Balistrieri when it closed in 1971. The final performance was given by Miles Davis. (Author's collection.)

Arena 1974 or '75

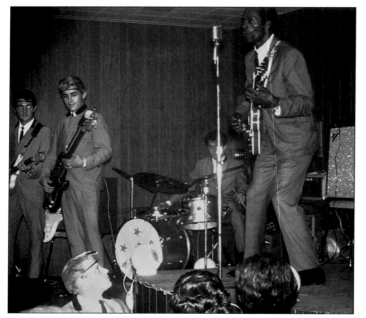

Monreal's on South Sixteenth Street was just one of several music clubs in Milwaukee to feature national rock-and-roll acts in the 1960s. House bands such as the Mojo Men played sets of their own before backing up a headliner like Chuck Berry (right). (Courtesy of Gary Myers.)

The Athena, at the intersection of 35th Street, Burleigh Street, and Fond du Lac Avenue, was a rock-and-roll dance club called Ken's in the early 1960s. It became the Athena in 1964 and Beneath the Street in 1966. A decade later, the club was renamed Fantasy's. Junior Brantley, Bill Haley and the Comets, Head East, Cheap Trick, Mountain, and Chicago (as the Big Thing) are some of the acts that played here. (Photograph by Gary Myers.)

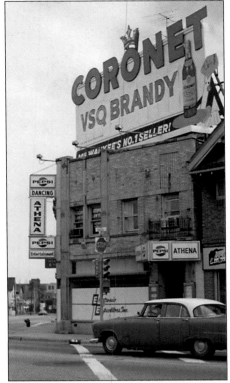

UWM 1973

Jim Liban (left) and Junior Brantley have been at the forefront of the local music scene for five decades. The duo often performed together in the blues-based band Short Stuff. They are pictured playing at the Wisconsin Area Music Industry (WAMI) award show in 1984. (Photograph by Tim Townsend.)

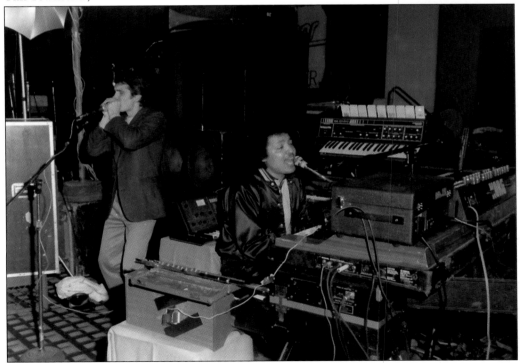

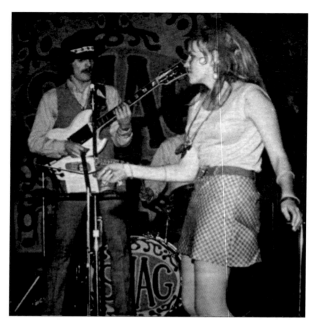

The Gordon Park Center at 827 East Locust Street once housed O'Brad's, a 1960s dance club that featured local bands like the Shags. In 1972, Joe and Brian Balistrieri took over and renamed it Hanna's. Dim lighting prevented patrons from paying too much attention to the torn carpeting and unfinished walls. Cheap Trick, Rory Gallagher, Roxy Music, Luther Allison, Lou Reed, Steely Dan, Joe Walsh, Manfred Mann, Taj Mahal, and Jo Jo Gunne are some of the acts that played here. The club closed in the late 1970s, and the building was torn down in 1982. (Photograph by Gary Myers.)

SAW DAN HICKS HERE in 1973

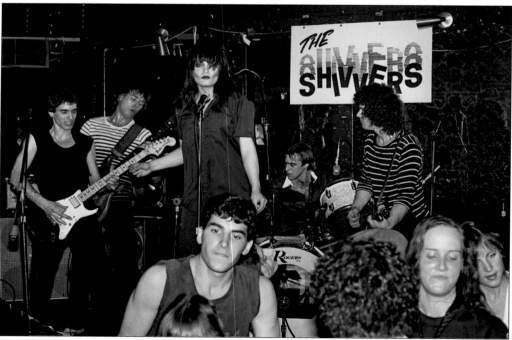

The Shivvers are pictured here on stage at the Starship around 1980. From left to right are Jim Eannelli, lead guitar; Richie Bus, bass; Jill Kossoris, vocals/piano; Jim Richardson, drums; and Mike Pyle, rhythm guitar. Although the group broke up several years later, the Shivvers's CDs still sell well in England and Japan, and an original 45 RPM of "Teen Line" can go for more than $300 on eBay. At age 16, Kossoris was a member of In A Hot Coma with Jerry Brish and Richard and Gerald LaValliere. She left to form the Shivvers, and the other three musicians, along with drummer Guy Hoffman, became the Haskels. (Courtesy of Jill Kossoris.)

Milwaukee's gaslight-era treasure, the Pabst Theater, once seemed an unlikely place to hold rock concerts, especially one featuring one with a rowdy fan base; however, a Black Sabbath concert held in 1971 was trouble-free and a big success. The show was the first undertaking by Daydream Productions, a local concert promotion company formed by Randy McElrath and Alan Dulberger. (Photograph by author.)

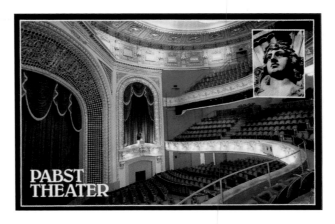

The Electric Ballroom operated from 1976 to 1979 inside a former movie theater located at Twenty-sixth and State Streets. Because of the auditorium's relatively small size, the venue quickly became a popular place to see bands on the way up (or the way down). The general-admission ticket policy gave audiences the chance to stand right in front of the stage. Acts that played here included Leslie West, Dr. Hook, Mott the Hoople (without Ian Hunter), Cheap Trick, Rick Derringer, Elvis Costello, Eddie Money, AC/DC, the Ramones, Budgie, Television, Todd Rundgren, Dave Edmunds, and Nick Lowe. (Inset, author's collection; photograph by author.)

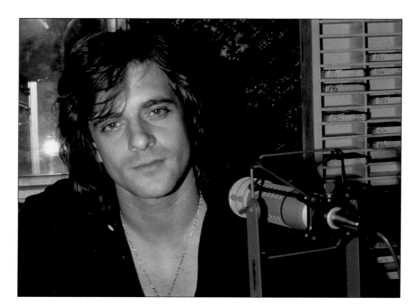

Eddie Money is pictured at WZUU for a round of interviews and pre-concert promotion. The singer was on tour to promote his first album and was scheduled to perform at the Palms later that night. (Photograph by Charlie McCarthy.)

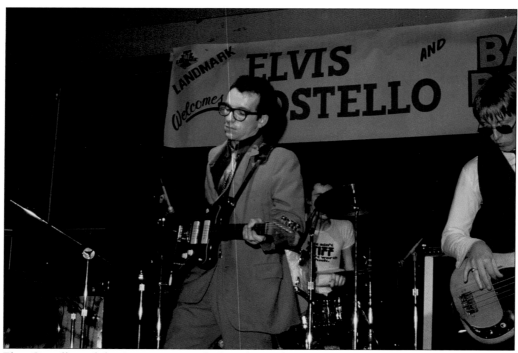

Elvis Costello and the Attractions made their first Milwaukee appearance at the Electric Ballroom on December 1, 1977. The audience was surprised, but delighted, when Costello and his band pushed their way through the crowd from the back of the venue and climbed on stage. Elvis Costello's many other area appearances include the Centre Stage Theatre, Auditorium, Alpine Valley, Riverside Theater, and Summerfest. (Photograph by author.)

8AW IN 1981

Ray Manzarek was in Milwaukee in 1977 to perform at the Palms nightclub. *MATC Times* editor Judi Anderson (left) asked the keyboardist about the Doors's musical legacy and his career following Jim Morrison's death. Although the Doors only played Milwaukee once (October 1, 1968), Manzarek returned for performances at Summerfest, Riverside Theater, Odd Rock Café, and Shank Hall. In 2010, he and Robby Krieger performed as the Doors at the Pabst Theater. Manzarek died in May 2013 at age 74. (Photograph by Chuck Barth/*MATC Times*.)

The Runaways were an all-girl teenage band from Los Angeles led by guitarist/vocalist Joan Jett. She also wrote most of the group's material. Fronted by bottle-blonde Cherie Currie (pictured), the Runaways recorded five albums and experienced moderate success between 1976 and 1979. The 2010 film *The Runaways* was based on Joan Jett's memoirs and starred Kristen Stewart as Jett and Dakota Fanning as Currie. (Photograph by author.)

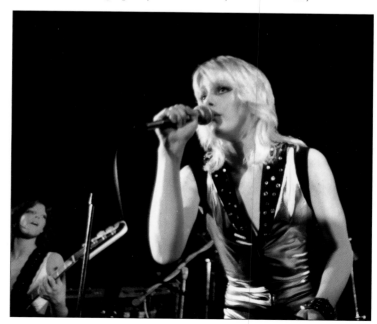

Guitarist Ronnie Montrose performed with his new band, Gamma, at the Palms on January 27, 1981. Montrose broke into the business a decade earlier when he was hired by Van Morrison to play on the album *Tupelo Honey*. Montrose joined the Edgar Winter Group and recorded the hit singles "Frankenstein" and "Free Ride" before starting his own band with singer Sammy Hagar. (Photograph by author.)

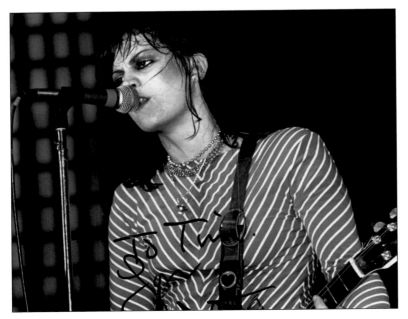

Joan Jett returned to the Palms in May 1982 with her band, the Blackhearts. After leaving the Runaways, Jett became a popular live act in small clubs and theaters drawing from a body of work that included "Crimson and Clover," "I Hate Myself for Loving You," "Do You Want to Touch Me," "Light of Day," and "Bad Reputation." (Photograph by Tim Townsend.)

Rick Derringer performed at the Times Cinema on August 21, 2007. Backstage after the show, bassist Charlie Torrez (left) relaxes with cinema owner David Glazer (center) and Derringer. Throughout much of the 1970s, Derringer was found playing in Johnny or Edgar Winter's band. His song "Rock and Roll Hoochie Koo" was an FM radio hit and can be found on a number of film soundtracks. (Photograph by Tim Townsend.)

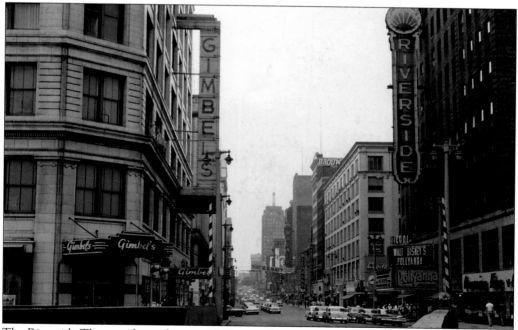

The Riverside Theater, shown here in 1960, was a huge motion picture theater with a stage. The acoustically perfect 2,500-seat auditorium was the favorite Milwaukee stop for big-band leaders Benny Goodman, Harry James, and Duke Ellington. In 1958, about 6,200 fans jammed the theater for New York City radio personality Alan Freed's rock-and-roll show with Chuck Berry, Buddy Holly, and Jerry Lee Lewis. (Author's collection.)

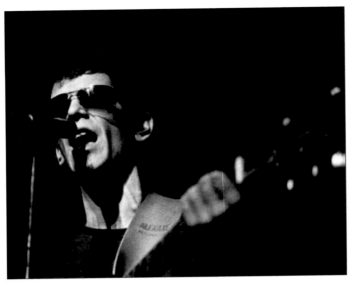

Lou Reed first performed in Milwaukee at Hanna's in 1973. Five years later, Reed's powerhouse show at the Riverside included "Street Hassle," "Gimme Some Good Times," "Satellite of Love," "Kicks," "Leave Me Alone," "I Wanna Be Black," "Walk on the Wild Side," "Coney Island Baby," "Heroin," "Dirt," "Sweet Jane," and "Rock And Roll," songs drawn from albums cut during the singer's most creative period. Lou Reed died in October 2012 at age 71. (Photograph by Jim Schnepf/MATC Times.)

SAW LOU REED w/ VIRGIL @ RIVERSIDE
ALSO SAW w/ Dr JOHN IN '73 @ ARENA

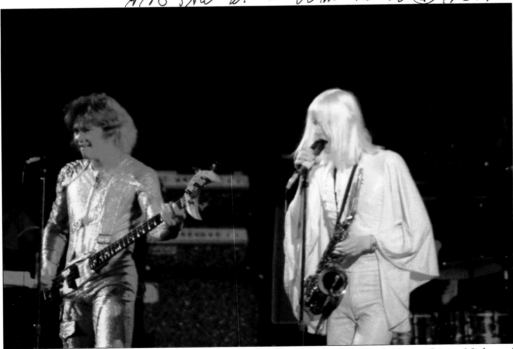

Edgar Winter burst into national prominence with the album *They Only Come Out at Night* and the hit single "Frankenstein." Hearing that song on the radio and experiencing it in concert were two different things, as he proved in a 1973 concert at the Riverside. With a heavily amplified Univox keyboard slung around his neck, Winter's ferocious rendition of the popular instrumental song concluded in a blaze of colored lights and synthesized sound. The show was attended by 2,600 people. (Photograph by author.)

British rockers Babe Ruth, fronted by lead singer Jenny Haan, appeared on a double bill with Roxy Music at the Riverside Theater in February 1975. The band kicked off a 1973 tour in support of the album *First Base* at Teddy's nightclub on Farwell Avenue. Lead guitarist Alan Shacklock was electrocuted on stage but was able to return and finish the show. The following year, the band opened for ZZ Top at the Arena. (Photograph by Rich Zimmermann.)

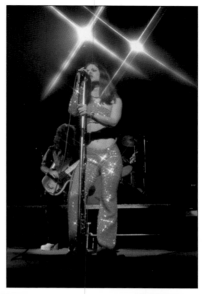

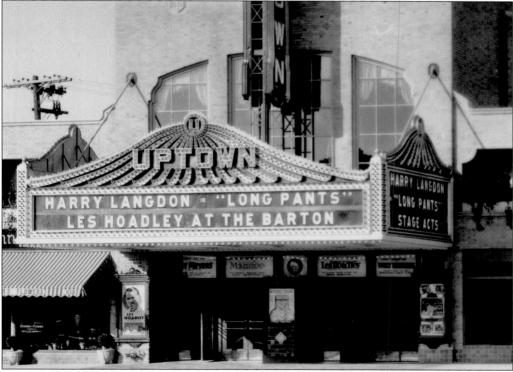

The Uptown Theater, at the intersection of Forty-ninth Street and Lisbon and North Avenues, opened in 1927. Although it was used primarily as a cinema, the theater was equipped with a stage for vaudeville shows. Beginning in the 1970s, the Uptown was used for concerts by Barry Manilow, Kansas, Patti Smith, Rainbow, Southside Johnny and the Asbury Jukes, Ronnie Spector, April Wine, U.K., Elvis Costello, Lou Reed, Gary Numan, Pat Travers, Steve Hackett, and Steppenwolf. (Photograph by Albert Kuhli.) *Springsteen 1975*

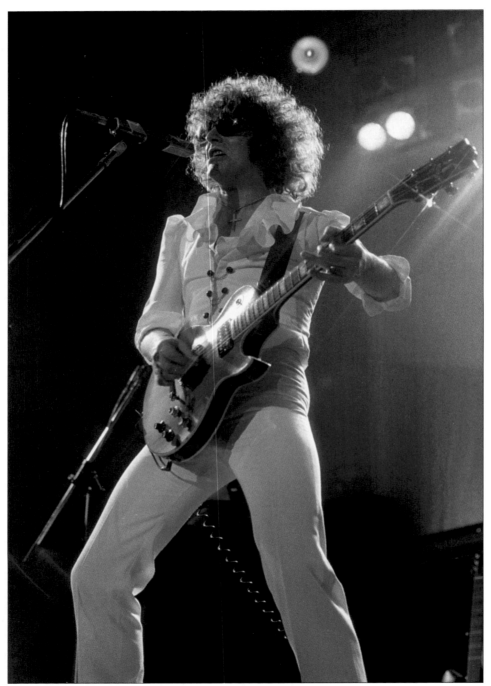

In 1974, Mott the Hoople front man Ian Hunter left the band and recorded "Once Bitten, Twice Shy" with ex–David Bowie guitarist Mick Ronson. The Hunter Ronson Band kicked off a national tour on April 18, 1975, with a fabulous show at the Uptown Theater. Other acts that played the theater that year included Barry Manilow, Supertramp, Hawkwind, Queen, Kansas, and Bruce Springsteen and the E Street Band. (Photograph by Rich Zimmermann.)

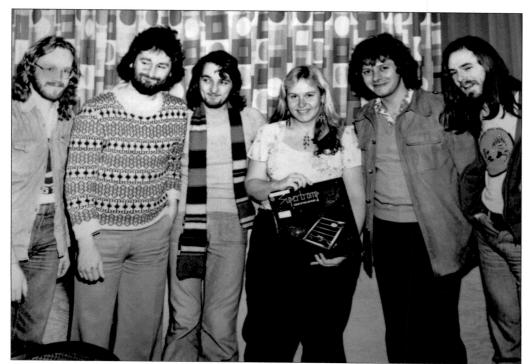

Riding on the success of their *Crime of the Century* LP, a 1975 US tour by British progressive rock band Supertramp brought them to Milwaukee's Uptown Theater in April. 93QFM on-air personality Bobbin Beam (center, with album) visited with members of the group (from left to right) John Helliwell, Rick Davies, Roger Hodgson, Bob Benberg, and Dougie Thomson at the radio station before the show. Beam joined WQFM in 1974, where she spent the next five years as the station became Milwaukee's top-rated FM rock choice. (Courtesy of Bobbin Beam.)

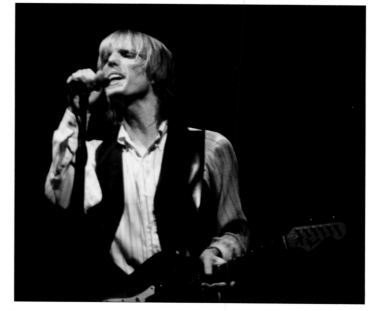

Tom Petty and the Heartbreakers played for 1,800 people in November 1979 at the Uptown Theater. He was touring in support of *Damn the Torpedoes*, which would go on to become one of the band's best-selling albums. (Photograph by author.)

SAW @ Alpine VALLEY 1986

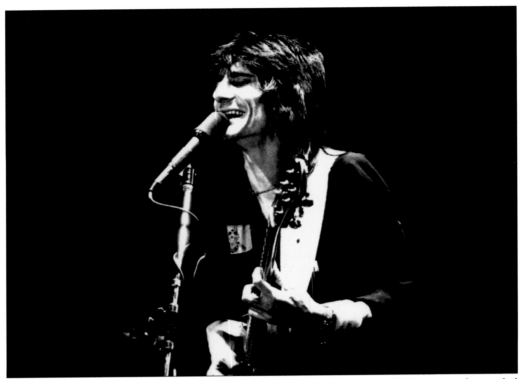

The New Barbarians, fronted by Ron Wood and Keith Richards, played a 1979 concert that ended with angry fans damaging the Arena. A local radio station irresponsibly hinted that Mick Jagger would appear with the group. As the show drew to a close, emotions reached the boiling point. Less than 100 people were arrested, but wire services across the country picked up the story. What was lost in the headlines about a rock concert riot was the fact that Richards and Wood (pictured later at a "make-good" concert to pay for repairs) used the opportunity to perform songs they could not do as part of a Rolling Stones show. (Photograph by author.)

The Liverpool-based band Echo and the Bunnymen played to a crowd of 800 at the Uptown Theater on March 20, 1984. The set list included "Going Up," "Never Stop," "Heaven Up Here," "The Cutter," and "Killing Moon." *Milwaukee Journal* critic Divinia Infusino praised the show but found singer Ian McCullough's obsession with the late Jim Morrison a bit much. (Photograph by Dennis Felber.)

Queen, led by the flamboyant Freddie Mercury, played their first Milwaukee show at the Uptown in March 1975. Brian May's signature guitar riffs and Mercury's near-operatic voice provided the band's distinctive sound that fused ear-splitting arena rock with classical music. While photographing the show, Rich Zimmermann fell from the stage into the orchestra pit. Shaken but uninjured, he got some great shots of a great performance. Queen went on to become one of the largest concerts draws in the world. Their reign ended in 1991 with Mercury's untimely death at age 45. (Photograph by Rich Zimmermann.)

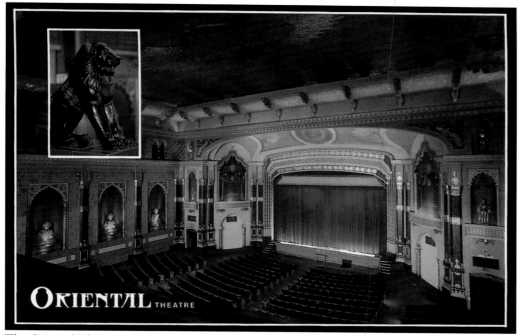

The Oriental Theatre opened in July 1927 at the corner of Farwell and North Avenues. Although primarily used as a motion picture theater, the Oriental began featuring live entertainment on a regular basis beginning in the 1960s. Liberace, Mario Lanza, Melanie, Ray Charles, Bob Dylan, Muddy Waters, the Siegel-Schwall Band, Short Stuff, Quicksilver Messenger Service, Canned Heat with John Lee Hooker, Taj Mahal, Otis Rush, the Nitty Gritty Dirt Band with Steve Martin, Jerry Garcia, Supertramp, Slade, Thin Lizzy, Iggy Pop, Rickie Lee Jones, the Talking Heads, the Pretenders, the Violent Femmes, INXS, Stevie Ray Vaughan, the Fine Young Cannibals, Tangerine Dream, Laurie Anderson, Andreas Vollenweider, R.E.M., and New Order have performed here. (Photograph by author.)

41

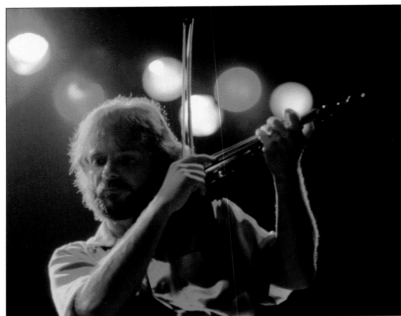

Prior to his appearance at the Oriental Theatre in 1986, violin virtuoso Jean-Luc Ponty had played on Milwaukee stages as a member of the Mahavishnu Orchestra, Return to Forever, and the Mothers of Invention. (Photograph by Dennis Felber.)

Arena
1974 or '75

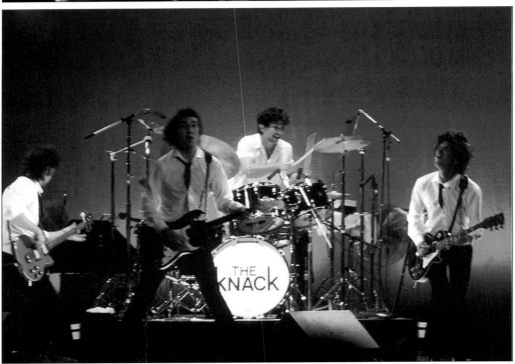

One of 1979's true overnight sensations, the Knack turned in a solid, riff-laden rock-and-roll show at the Oriental Theatre on September 27. Drawing heavily on songs from their debut album, *Get the Knack*, the band closed the show with their hit single, "My Sharona." Subsequent albums from the group failed to achieve the success of the first, and by 1994 the Knack returned to Milwaukee, playing to 320 people at the Rave. (Photograph by Tim Townsend.)

British glam-rockers Roxy Music, led by charismatic vocalist Bryan Ferry, headlined an April 1979 show at the Oriental. On their first visit to Milwaukee, the band played Hanna's nightclub on East Locust Street. Subsequent shows in town found them opening for Frank Zappa and the Mothers of Invention at the Arena and on a double bill at the Riverside Theater with fellow Brits Babe Ruth. Bryan Ferry performed a solo show at the Performing Arts Center in 1988. (Photograph by author.)

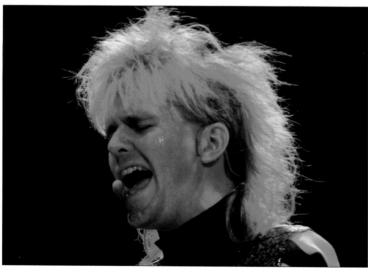

British synthesizer ace Howard Jones played to a sellout crowd at the Oriental in June 1985. The two-hour show was carried by Jones's abundant talent on keyboards and a pop-savvy collection of songs garnered from two studio albums. (Photograph by Dennis Felber.)

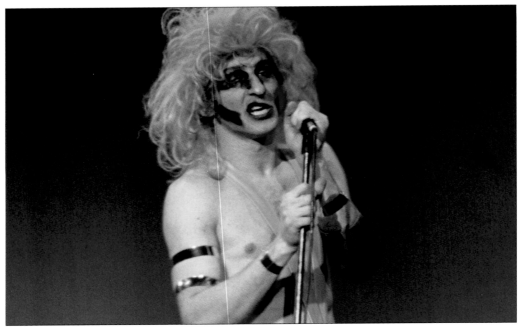

The Tubes, led by flamboyant front man Fee Waybill, brought their satirical, cynical rock-and-roll show to the Oriental in April 1979. More style than substance, the Tubes's songs paled in comparison to their vaudeville stage antics. For "White Punks on Dope," Waybill assumed the persona of Quay Lewd, a doped-up, burned-out rock star in six-inch platform shoes. (Photograph by author.)

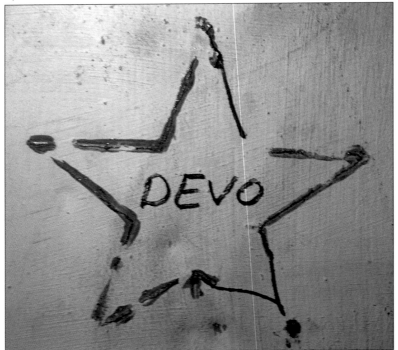

The quirky new-wave band Devo performed at the Oriental in 1980. A mark that a member of the group left on a dressing room door beneath the theater's stage survives to this day. (Photograph by author.)

Three

"It's Only Rock and Roll (but I Like It)"

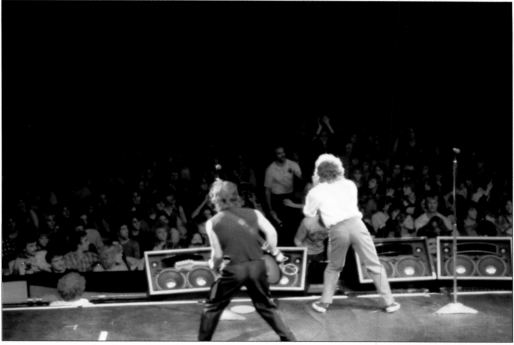

For many years, the Arena (1950) and Auditorium (1909) were the places promoters staged large concerts. Performers here included the Beach Boys, Johnny Cash, the Beatles, Ray Charles, the Rolling Stones, Dave Clark Five, James Brown, the Doors, Steppenwolf, Jimi Hendrix, Led Zeppelin, the Grateful Dead, Rod Stewart, Deep Purple, Frank Zappa, Elvis Presley, Yes, Jethro Tull, Alice Cooper, David Bowie, Santana, Black Sabbath, Bob Seger, KISS, Frank Sinatra, Tom Jones, Bad Company, Bob Dylan, Diana Ross, Queen, Heart, Genesis, Prince, Bruce Springsteen, Lynyrd Skynyrd, Aerosmith, AC/DC, the Cars, Tom Petty, the Clash, and the Police. (Photograph by author.)

1970 1980 1981 1977 1972 45
 1978

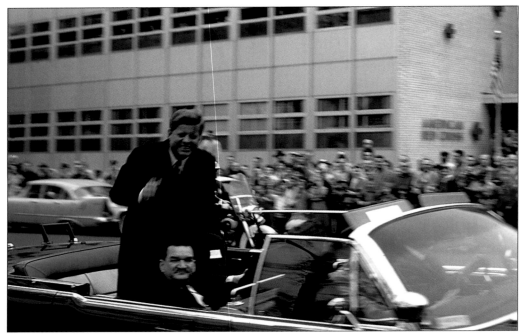

Pres. John F. Kennedy campaigned in Milwaukee on May 12, 1962. The youngest man to ever hold the highest office in the United States, Kennedy's election sent vibrations throughout America that resulted in the beginning of the "youth decade." Beer, soft drinks, cosmetics, fast food—and most notably the music industry—quickly established a rapport with the generation of baby boomers to access their considerable disposable incomes and predictable spending habits. (Photograph by Leonard A. Widen.)

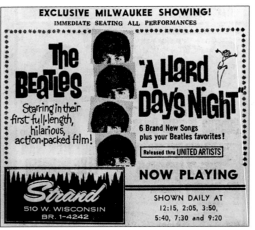

The Beatles's first feature-length film, *A Hard Day's Night*, opened in Milwaukee on Wednesday, August 26, 1964, at the Strand Theater. Moviegoers began arriving at 5:00 a.m., and by midmorning the line extended around the block. When the Strand was torn down in 1979, some vintage Beatles graffiti was exposed during the demolition. (At left, courtesy of *Milwaukee Journal Sentinel*; at right, photograph by author.)

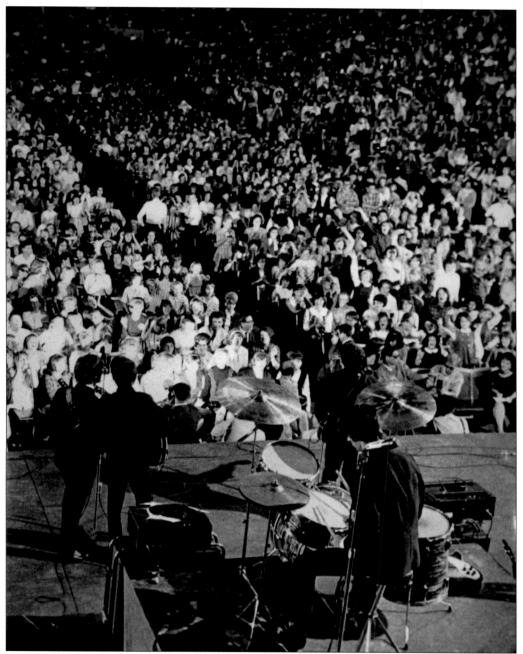

In 1964, promoter Nick Topping offered the Beatles $20,000 to include Milwaukee on their US tour that fall. As the group played only 23 large-market cities, it was a virtual certainty that the Milwaukee show happened because of Topping's interest. A sold-out crowd of 12,000 paid $3, $4, and $5 to see the Beatles on September 4 at the Arena. "The Beatles question aspects of religion, education, economic, and social systems," said Dr. Charles W. Landis, director of mental health for Milwaukee County, at the time. "Teens find this appealing, because they are at a questioning period in their own lives." (Courtesy of Alexandra Topping.)

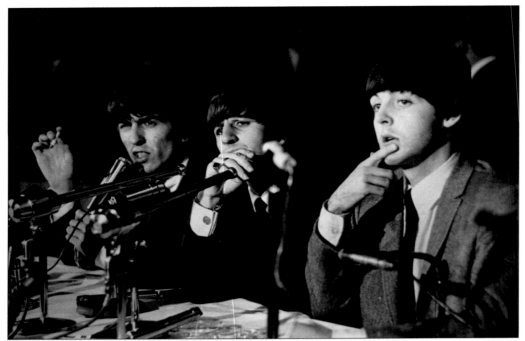

Prior to the show at the Arena, from left to right, George Harrison, Ringo Starr, and Paul McCartney attended a press conference at the Coach House Motor Inn. John Lennon was excused to rest a sore throat. While fielding reporters' questions, McCartney expressed chagrin that the police escorts would not drive them past fans who gathered at the airport of the hotel. "They stood there for hours to welcome us," he said. "It seemed a bit mean not to be able to give them a wave." (Courtesy of Alexandra Topping.)

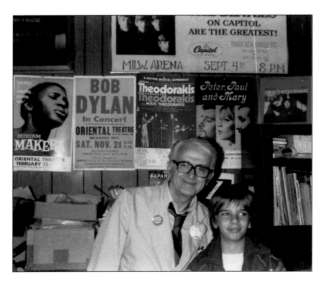

After serving in World War II, Nick Topping (left) came home to Milwaukee and started International House, a unique store that carried Greek foods, cheeses, books, and music from all over the world. It was Topping's love of music that led him to bring the Beatles to town for their first—and only—Wisconsin appearance. He also held concerts by Pete Seeger, Bob Dylan, and South African folksinger Miriam Makeba at the Oriental Theatre and the Dave Clark Five and Peter, Paul and Mary shows at the Auditorium. Topping passed away in 2007 at the age of 89. (Courtesy of Alexandra Topping.)

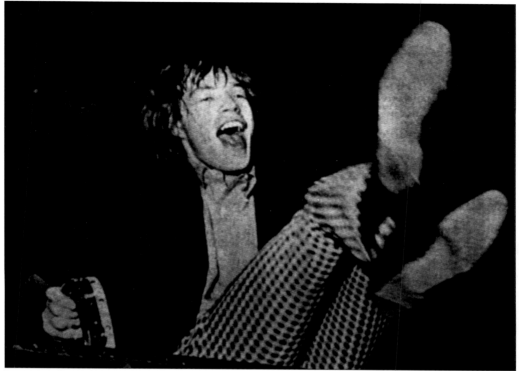

In 1964, the Rolling Stones drew a small audience to the Auditorium. The *Milwaukee Journal* gleefully noted that 4,992 seats went empty. "Unless someone teaches guitar chords to chimpanzees, the visual ultimate has been reached. With shoulder length hair and high heeled boots, they seemed more feminine than their fans." When the Stones returned in 1965, a number-one record, *Get Off My Cloud*, boosted attendance to 3,343 people, but as far as the papers were concerned, a $10,000-payday for 30 minutes and nine songs was highway robbery. It would be 10 years before the band played in town again. (Courtesy of the *Milwaukee Journal Sentinel*.)

On Led Zeppelin's 1969 tour, they played the Midwest Rock Festival at Wisconsin State Fair Park in West Allis. In July 1973, a show at the Arena in Milwaukee was part of a 30-city tour that broke attendance records and grossed more than $4 million. (Author's collection.)

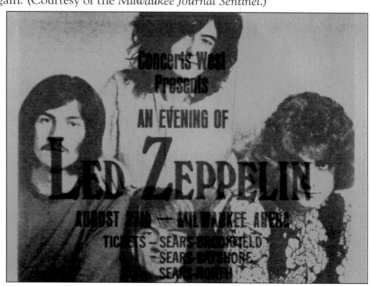

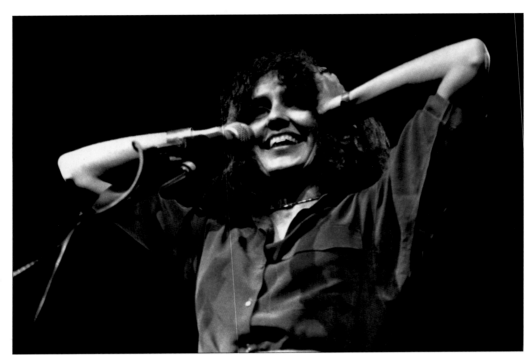

The sometimes-controversial activist/folksinger Joan Baez performed at the Performing Arts Center on July 19, 1979. Without the benefit of a band or backup singers, she accompanied herself on the guitar and encouraged the audience to sing along on spirituals like "Amazing Grace" and "Swing Low, Sweet Chariot." Baez also used some of her time on stage to encourage Milwaukeeans to help Vietnamese refugees assimilate in the community. (Photograph by Len Sadorf.)

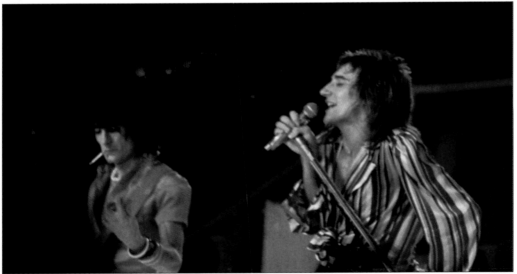

The Faces's Ron Wood (left) and Rod Stewart played before 2,800 people on a double bill with Deep Purple. Wood and Stewart were the kings of loud, fuzz-drenched, good-time rock until 1975. Ron Wood joined the Rolling Stones, and Rod Stewart pursued a solo career. (Photograph by author.)

In November 1971, guitarist Joe Walsh fronted a hard-rock trio, the James Gang, at the Arena. Although the band enjoyed moderate success with the singles "Funk #49" and "Walk Away," Walsh left a few months later to form another band called Barnstorm. The opening act for the James Gang was John Mayall and the Bluesbreakers. (Photograph by Rich Zimmermann.)

saw w/ EAGLES 1975, Co. STADIUM

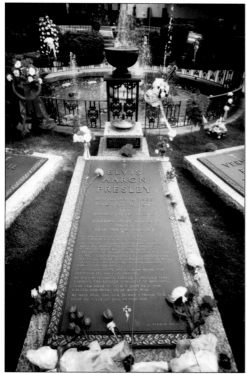

Elvis Presley didn't make it to Milwaukee until 1972, but when he did, 10,055 die-hard fans packed the Arena for a 54-minute show. When Presley returned five years later, he seemed old and tired. A sellout crowd watched him perform for 70 minutes without an encore. At one point, Elvis forgot the words to "My Way," reading them from a piece of paper. Four months later, he was dead at age 42. (Photograph by author.)

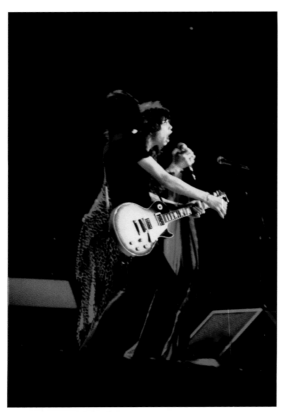

Randy McElrath and Alan Dulberger formed a concert promotion company called Daydream Productions in 1971. Their first show that year was Black Sabbath at the Pabst Theater. Daydream eventually put its competitors out of business, and by the mid-1970s Dulberger and McElrath were bringing Aerosmith, Deep Purple, and most of the other nationally touring rock acts to town. (Courtesy Mary Skanavis.)

For David Bowie's debut performance in Milwaukee in October 1974, a significant portion of the audience showed up wearing Ziggy Stardust–inspired makeup and clothing, expecting to see a high-energy concert based on Bowie's recent *Diamond Dogs* album. But by the time the tour reached Milwaukee, the singer had discarded the glam-rock elements from the show, instead performing as a white soul singer. When Bowie returned a few years later, those who purchased tickets at least had a better idea of the show they would be seeing. (Photograph by Rich Zimmermann.)

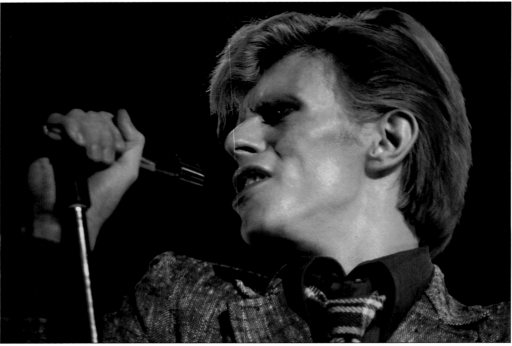

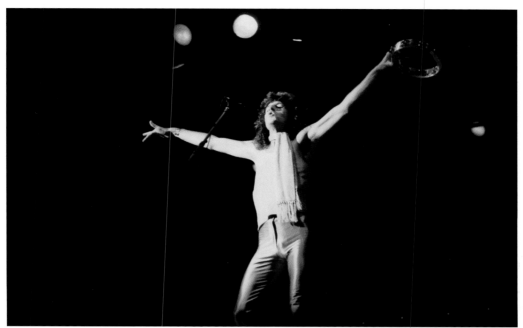

Kevin Cronin, the vocalist for REO Speedwagon, is seen here during a sold-out Milwaukee show. Audiences took to the hardworking band in the early 1970s as they worked their way up to the large venues. Before the band found success with *Ridin' the Storm Out*, it was not unusual to find them playing at Hanna's, Teddy's, or Rev's Flying Circus. Their 1977 live album, *You Get What You Play for*, was a breakout success, selling more than two million copies. (Photograph by author.)

In 1975, the Allman Brothers band played a two-and-a-half hour show for 8,500 people at the Arena as part of the Win, Lose, or Draw Tour. Behind the scenes, Gregg Allman (pictured) was under federal investigation for cocaine trafficking. This, plus a battle for creative control of the band's output, caused a rift among the members that never fully healed. Bluesman Muddy Waters and his band opened for the Allmans. (Photograph by author.)

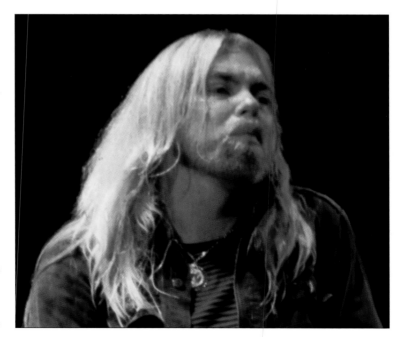

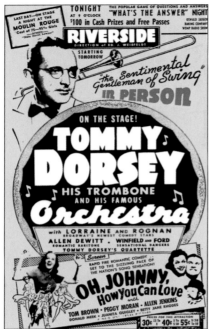

In 1940, Tommy Dorsey's new vocalist, Frank Sinatra, joined the band in Milwaukee and performed at the Riverside Theater. The bit in *The Godfather* about the bandleader who would not let Johnny Fontaine out of his contract until Vito Corleone made him "an offer he couldn't refuse" is based on this bandleader and that singer. More than a quarter century later, Sinatra finally returned to the city for a concert at the Arena on May 6, 1976. He made several more area appearances in the years before his death in 1998. (Author's collection.)

Alice Cooper stopped in for some pre-concert shtick at WZUU in 1977. In the film *Wayne's World*, Cooper discusses Milwaukee with Wayne Campbell: "Well, I'm a regular visitor here, but Milwaukee has certainly had its share of visitors. The French missionaries and explorers were coming here as early as the late 1600s to trade with the Native Americans . . . it's pronounced 'mill-e-wah-que,' which is Algonquin for 'the good land.' " (Photograph by Charlie McCarthy.)

Cooper's Lace and Whiskey Tour hit Milwaukee on August 25, 1977. Cooper ditched the scary stuff in favor of a horror-comedy stage show complete with machine gun–toting chickens, a giant purple cyclops, and dancing black widow spiders. WZUU's Charlie McCarthy wore a long, black robe on stage to play the part of an inmate in an insane asylum. "I was told to shuffle around while Alice sang, 'Welcome to My Nightmare,' " McCarthy said. "It was a blast!" (Photograph by Charlie McCarthy.)

Tommy Shaw (right) from Styx is pictured at WZUU with on-air personality Charlie McCarthy. The band was in town for a July 27, 1977, show at the Riverside. Styx first performed in Milwaukee at Teddy's in January 1973, returning six months later to play Oliver's, a rock club at Milwaukee and Wells Streets. They also played the Uptown in March 1975, opening for Queen and Kansas. No one remembers why Shaw was wearing boxing gloves. (Courtesy Charlie McCarthy.)

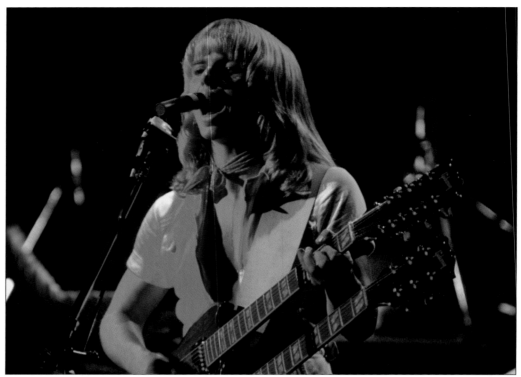

Guitarist/vocalist Tommy Shaw from Styx performs at the Auditorium on December 30, 1977. This was the final show of the band's Grand Illusion Tour. Released six months earlier, the album generated two hit singles, "Come Sail Away" and "Fooling Yourself," while going on to sell three million copies. (Photograph by Dennis Felber.)

An audience of 10,000 jammed the Arena in May 1980 for a concert by Bob Seger & the Silver Bullet Band. Seger was on tour to support the release of his sixth album, *Against the Wind*. Prior to working with the Silver Bullet Band, Seger's group was called the Bob Seger System. They appeared at Summerfest in 1968 and Teddy's on Farwell Avenue in December 1973. (Photograph by Charlie McCarthy.)

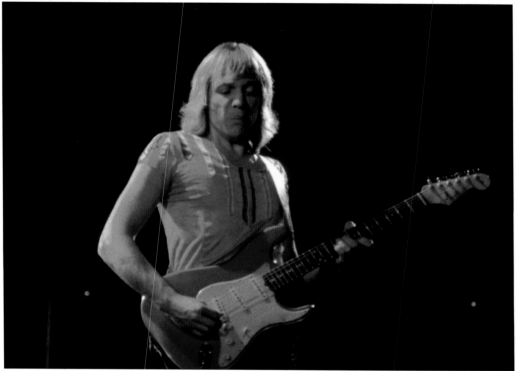

On tour to promote his third album, *For Earth Below*, Robin Trower appeared in front of 6,400 fans at the Auditorium in April 1975. The 75-minute set included new material as well as "Little Bit of Sympathy" and "Too Rolling Stoned" from the *Bridge of Sighs* LP. The guitarist left the popular British group Procol Harum in 1973 to form his own band with bassist James Dewar on vocals. Trower subsequently performed at Summerfest, Shank Hall, Billy's Old Mill, Marty Zivko's Ballroom, and the Modjeska Theater. (Photograph by Dennis Felber.)

A self-taught musician, Frank Zappa began recording in 1966. Backed by the Mothers of Invention, his distinctive compositions fused jazz, classical, and rock. John McLaughlin, Jean-Luc Ponty, and Lowell George were among the musicians who played in Zappa's band at one time or another. During an interview, one of the band's roadies admitted that Zappa was never without a cigarette in his hand and drank at least 30 cups of coffee a day. Zappa died in 1993 at the age of 53. (Photograph by Dennis Felber.)

MILW AEENA 1974 or '75

In September 1978, the four member of KISS simultaneously released solo albums. Gene Simmons (pictured) made a promotional stop at radio station WZUU to talk about his record. At that point in the band's evolution, their faces had not been revealed to the public, and Simmons covered up with a black scarf during the photography session. (Photograph by Charlie McCarthy.)

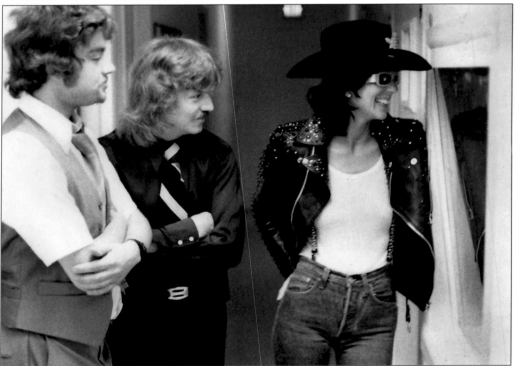

Pop icon Cher, who was in a relationship with Simmons at that time, watched him in the WZUU studio from a window in the hallway. Station program director Bill Shannon (left) and head of publicity Dieter Sturm accompanied her. Not coincidentally, Cher had just signed on Casablanca Records, whose major client was KISS. She produced the million-selling disco single "Take Me Home" before separating herself from the label—as well as Simmons. (Photograph by Charlie McCarthy.)

In November 1979, Foreigner, led by vocalist Lou Gramm, was on tour in support of their third album, *Head Games*, released eight weeks prior. The band's previous albums, *Foreigner* and *Double Vision*, sold more than nine million copies in the United States alone. (Photograph by author.)

During a 1980 show at the Arena, Jethro Tull took 7,700 fans on a 90-minute mystical jaunt via flute, violin, keyboard, mandolin, and guitar with English folk music ramped up for modern-rock sensibilities. The band's front man, Ian Anderson, was the puckish, medieval sorcerer who presided over the show. When they first played Milwaukee's Midwest Rock Fest in 1969, Jethro Tull was a progressive folk-blues band. A decade later, the group's classic sound had been defined by albums like *Aqualung* and *Thick as a Brick*. (Photograph by Jack Long.)

Meat Loaf is seen relaxing at WZUU in between interviews in August 1978. Later, the singer appeared at the Performing Arts Center, doing songs from the hit album *Bat Out of Hell.* This was Meat Loaf's second Milwaukee appearance, having performed at the Electric Ballroom just a few months earlier. (Photograph by Charlie McCarthy.)

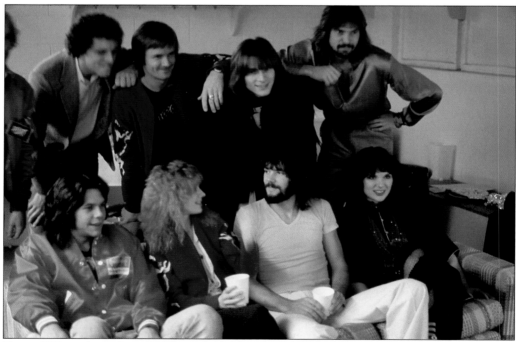

Nancy Wilson (seated, second from the left) and Ann Wilson (seated, far right) relax with the members of Heart backstage at the Arena in July 1980. The band was on tour in support of the *Bebe Le Strange* album. About 5,000 people came out for the show, which included covers of Janis Joplin's "Down on Me" and the Righteous Brothers's "Unchained Melody." The show was recorded for possible inclusion in a live album, and as a result some excellent audio downloads are available. (Photograph by Charlie McCarthy.)

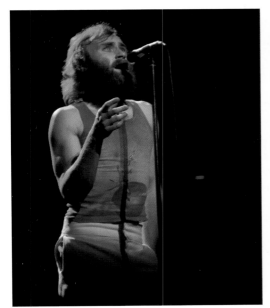

Phil Collins (right) of Genesis firmly established himself as a singer when he took over the lead vocals on the band's first tour following the departure of Peter Gabriel (left). The photograph of Collins was taken a decade after the Gabriel shot when Genesis was at the top of their game, selling out huge venues. (Photographs by Dennis Felber.)

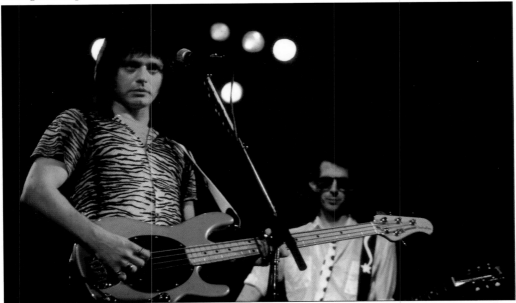

The Cars's first album hit big in 1978, selling a million copies by the end of the year. It stayed on the charts for 139 weeks with "Bye Bye Love," "Just What I Needed," "Moving in Stereo," "You're All I've Got Tonight," "Good Times Roll," and "My Best Friend's Girl" getting heavy FM radio airplay. Led by Benjamin Orr (left) and Ric Ocasek, the Cars performed in Milwaukee three times by 1980. Minimalist stage designs and a lack of audience rapport made the Cars better heard and not seen. (Photograph by author.)

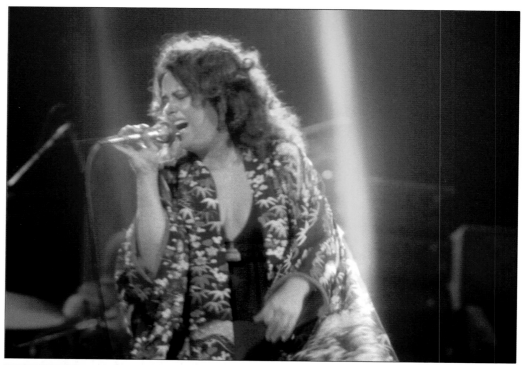

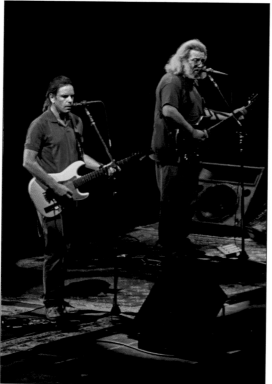

Grace Slick, the singer for Jefferson Starship, performed at a July 1976 concert at the Arena. Despite stiff competition from the bands playing at Summerfest, Starship drew more than 10,000 fans to their show. (Photograph by Rich Zimmermann.)

SAW AIRPLANE un EAU CLAIRE 1970

Bob Weir (left) and Jerry Garcia of the Grateful Dead sang "Hell in a Bucket," "Stagger Lee," "Fire on the Mountain," and "Truckin' " during an April 1989 show at the Arena. Weir also performed "Mexicali Blues," and bassist Phil Lesh sang "Box of Rain." (Photograph by Jeff Dobbs.)

SAW @ ARENA 1980

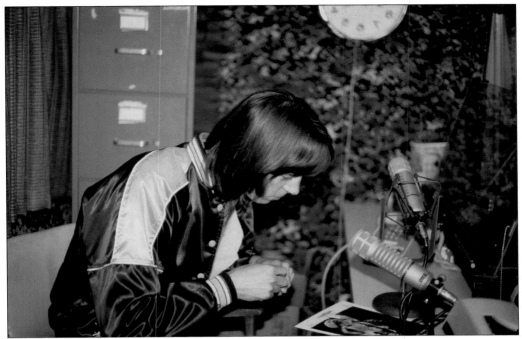

Boston guitar player Tom Scholz signs autographs at radio station WZUU in 1979. Boston's first Milwaukee-area performance took place at Rev's Flying Circus in Waukesha on October 5, 1976. Six weeks later, the band opened for Foghat at the Arena. This time, nearly 12,000 fans packed the Arena for the final show of a tour that began eight months earlier in Lexington, Kentucky. The opening act for all 138 shows on the tour was Sammy Hagar. Boston did not return to the area until 1987, when they did a four-night engagement at Alpine Valley. (Photograph by Charlie McCarthy.)

Members of the rock band Boston challenged radio station WZUU's on-air personalities to a charity basketball game held at Wauwatosa West High School on August 30, 1979. Disc jockey Charlie McCarthy attempts a hook shot while being guarded by guitarist Tom Scholz during the Friday evening event. (Photograph by Dave Gilo, courtesy of Charlie McCarthy.)

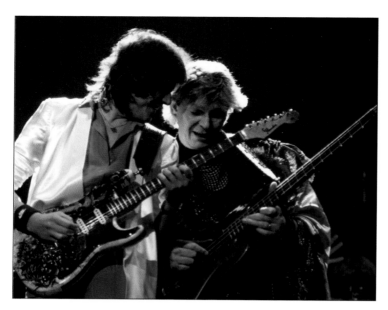

Pictured here are Trevor Rabin (left) and Chris Squire of Yes. The band acquired a reputation for putting on shows with sensational lighting and visual effects that may have overpowered a group of lesser musicians. But Rick Wakeman typically used eight or nine different keyboards during a performance, and Squire played several different bass instruments, including one with eight strings. (Photograph by Dennis Felber.)

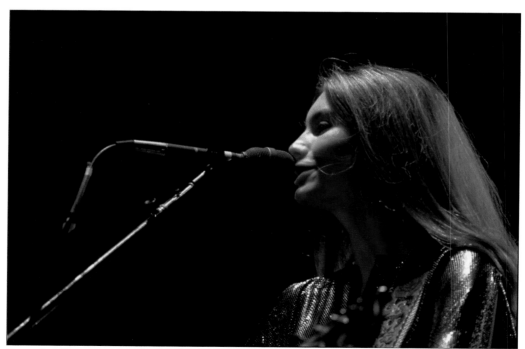

Emmylou Harris was at the forefront of country-rock in the early 1970s. A number of her early performances in Milwaukee were at smaller venues or theaters, such as the Oriental. As her popularity continued to grow, shows featuring Harris and the Hot Band were held at the Auditorium, Pabst Theater, and the Performing Arts Center. (Photograph by author.)

SAW @ SUMMER fest 1980
" " ARENA 1981

It is hard to believe that one of the biggest rock bands on the planet did not play Milwaukee until 1982. The Who came close a number of times, most notably with shows at Lake Geneva's Majestic Hills Theater in August 1968 and again in June 1969. The set list in 1968 consisted primarily of material from *The Who Sell Out*, while the 1969 show included almost all the songs from *Tommy*. When the band played Madison's Memorial Coliseum in March 1976, they included numbers from *The Who by Numbers*. The Who returned to the area for a three-night stand at Alpine Valley in 1989. (Photograph by Hank Grebe.)

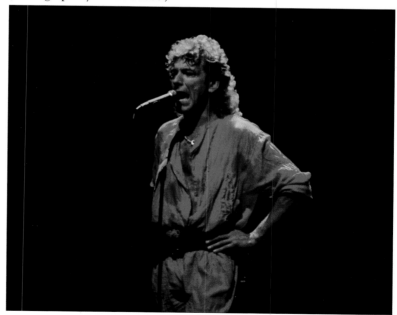

After Led Zeppelin's disintegration in 1980, both Robert Plant (pictured) and Jimmy Page pursued solo careers with moderate success. The two reunited in 1995 for an American tour that included a May 1 stop at Milwaukee's Bradley Center. Not surprisingly, the 19-song set list included 15 by Led Zeppelin. (Photograph by Dennis Felber.)

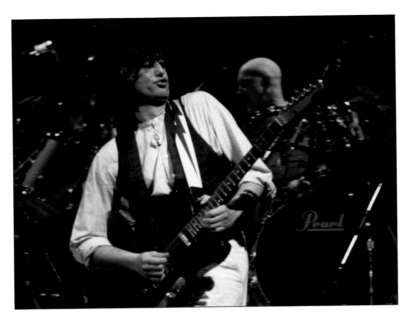

Jimmy Page's post–Led Zeppelin career has included collaborations with Paul Rodgers and David Coverdale. Page and Robert Plant's 1995 US tour fueled rumors of a Led Zeppelin reunion, and it finally happened in London in 2007. (Photograph by Dennis Felber.)

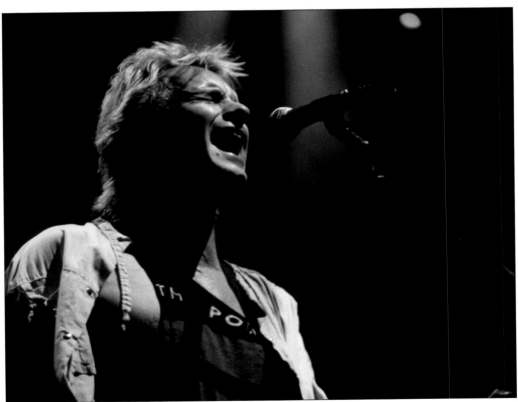

Sting performed at the Riverside on December 7, 1999. The set list included songs from the Police era as well as his solo years. Sting was in the Police, along with Andy Summers and Stewart Copeland, from 1977 to 1983. They regrouped briefly in 2007. (Photograph by Dennis Felber.)

John Michael Osbourne, better known as Ozzy Osbourne, first performed in Milwaukee with Black Sabbath in 1971. Ozzy left the band in 1979 after nearly 10 years to pursue a solo career. *The Blizzard of Ozz, Diary of a Madman,* and *Bark at the Moon* were all among the best-selling albums of the 1980s. Ozzy and Black Sabbath first reunited in 1997, with the most recent tour occurring in 2012. (Photograph by Dennis Felber.)

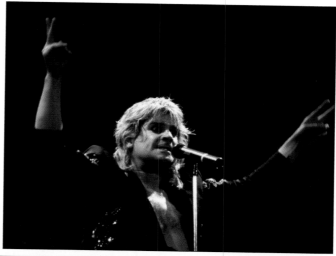

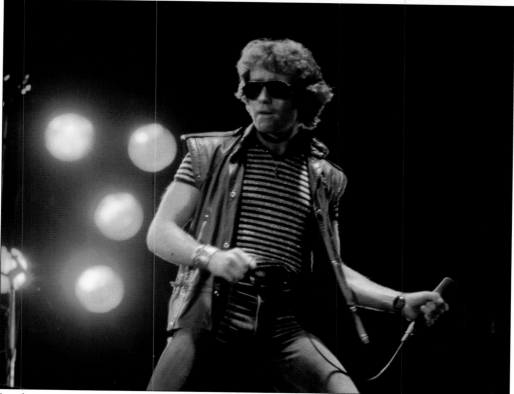

Lead singer Paul Rodgers of Bad Company is pictured at the Arena during a 1991 show on the Holy Water Tour. The British supergroup was formed in 1973 with former members of Free, Mott the Hoople, and King Crimson. After filling the largest arenas and stadiums for a decade, band members went their separate ways. Bad Company gets together every few years, and in the meantime the musicians play solo shows or perform in other bands. In 2005, Rodgers and Queen began a world tour, stopping in Milwaukee for a March 27, 1996, show. (Photograph by Dennis Felber.)

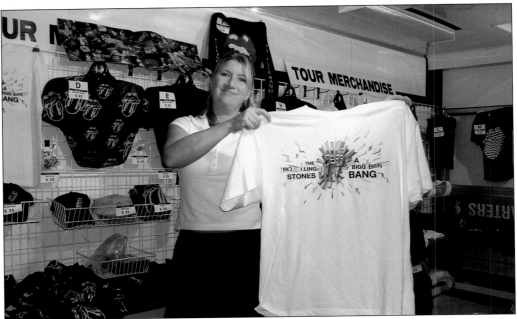

Midway through the Rolling Stones's two-and-a-half-hour show at the Bradley Center in September 2005, the band walked out to a small stage in the center of the room. Lucky fans were able to get right up to the stage for a four-song mini-set that included "Miss You," "You Got Me Rockin'," and "Honky Tonk Women." Earlier in the evening, the band was joined on stage by Buddy Guy for a cover of "Night Time is the Right Time." (Photograph by author.)

The Rolling Stones's Bigger Bang Tour included several merchandise booths on both levels of the Bradley Center. The basic T-shirt was selling for $35, while prices for the deluxe shirts, jackets, and other apparel escalated accordingly. By comparison, the least expensive shirt sold at the 2013 shows was $55. (Photograph by author.)

Rock aficionado Alex Skanavis grew up listening to his favorite bands on compact discs. While still in middle school, Skanavis began to acquire original vinyl records by Jimi Hendrix, the Rolling Stones, Black Sabbath, Led Zeppelin, the Beatles, and other arena rock groups from the 1960s, 1970s, and 1980s. His collection, which has grown to several hundred albums, includes a number of rare and valuable LPs. (Photograph by Dave Gilo.)

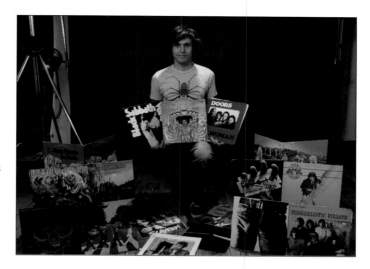

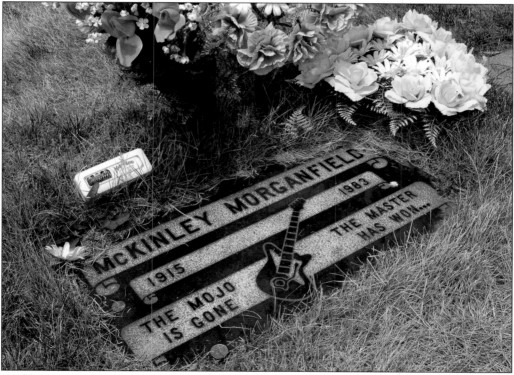

Muddy Waters, born McKinley Morganfield in 1913 in Mississippi, was among the world's greatest influences on modern rock music. He began playing black nightclubs in Chicago in 1948 only to discover that his guitar and voice could not rise above the ambient noise. Waters plugged his guitar and a microphone into an amplifier and cranked the volume to become the commanding presence in the room. Mick Jagger and Keith Richards named their band after his 1950 song, "Rollin' Stone." There is no rock musician, black or white, that hasn't been touched by the late, great Muddy Waters. More than anyone, he was the father of rock and roll. (Photograph by author.)

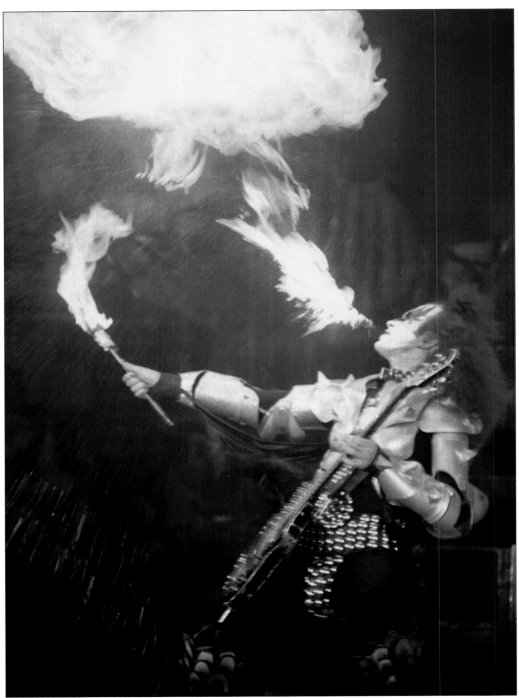

One of the most spectacular rock acts to ever hit a stage, no KISS show is complete without Gene Simmons doing his fire-breathing stunt. The band struggled for three years, touring relentlessly to build an audience. Against all odds, their 1975 album *KISS Alive* sold millions of copies and elevated the band to headliner status. (Photograph by Dennis Felber.)

Four

"It's All Right Now, in Fact It's a Gas"

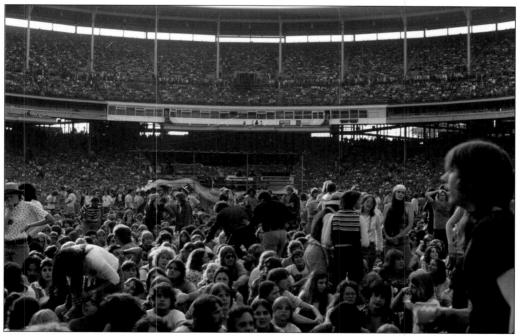

Concerts expected to draw 40,000 or 50,000 attendees were staged at Milwaukee County Stadium. The Rolling Stones, Pink Floyd, Paul McCartney, Billy Joel & Elton John, Simon and Garfunkel, Aretha Franklin, Crosby Stills & Nash, Fleetwood Mac, Jimmy Buffett, Ted Nugent, Heart, Journey, Cheap Trick, Foreigner, .38 Special, April Wine, Kenny Loggins, Peter Frampton, Marvin Gaye, Al Green, the Temptations, Smokey Robinson, B.B. King, Emmylou Harris, the Staple Singers, Frankie Avalon, and James Brown all performed here. The stadium was demolished in 2000 to make way for a more modern facility: Miller Park. (Photograph by Rich Zimmermann.)

Summerfest 1987

1999

Mick Jagger of the Rolling Stones is seen in 1975 at Milwaukee County Stadium. The band opened with "Honky Tonk Woman." Jagger shed his lime green satin baseball jacket, and the Stones roared into "All Down the Line," "If You Can't Rock Me," and "Star, Star." Milwaukee was the fourth stop on a 27-city summer tour that year. With new member Ron Wood on board, the band delivered muscular versions of songs from "Exile on Main Street," "It's Only Rock and Roll," and "Goat's Head Soup." Rufus featuring Chaka Khan and the Eagles with newbie Joe Walsh opened for the Stones. (Photograph by author.)

I was there

David Gilmour, guitarist for Pink Floyd, dodged raindrops during the spectacular Milwaukee County Stadium show in June 1975. Intermittent rain showers halted the performance several times as the road crew hurried to cover the sound equipment with heavy tarps. Many concertgoers swear that the rain stopped and the clouds parted just as the band was singing, "I'll see you on the dark side of the moon." The event was sold out, drawing close to 50,000 fans. (Photograph by Rich Zimmermann.)

Seattle-based rockers Heart, led by Ann and Nancy Wilson, were part of 1978's Grand Slam Jam at the stadium. Also on the bill were Cheap Trick and headliner Ted Nugent. (Photograph by Tim Townsend.)

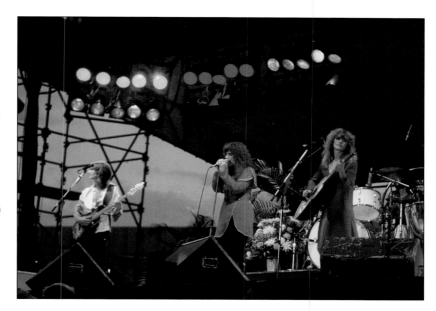

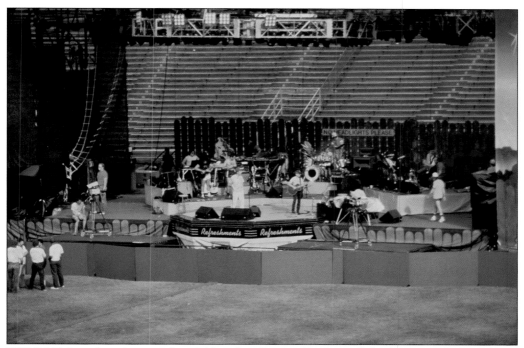

WZUU-FM was broadcasting from Milwaukee County Stadium all day long on July 27, 1983, to celebrate Paul Simon and Art Garfunkel's return to Milwaukee. Radio listeners heard bits and pieces of the band doing a sound check as the stadium was being readied for that evening's show. (Photograph by Charlie McCarthy.)

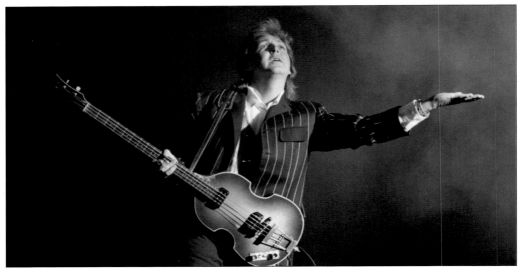

Paul McCartney rocked County Stadium in 1993 with a set that mixed favorite songs from the Beatles and Wings with some newer material. He also performed a cover of "Good Rockin' Tonight," an early Elvis hit from the Sun Records era. The weather was less than cooperative, and most of the show was in the rain. Approximately half of the 48,000 in attendance were shielded from the elements, while the other half covered themselves up and enjoyed the show. McCartney walked on stage and said, "Welcome, Milwaukee. That's the nicest selection of raincoats I've seen all year." McCartney returned to Milwaukee in July 2013 for a concert at Miller Park. (Photograph by Chris Corsmeier.)

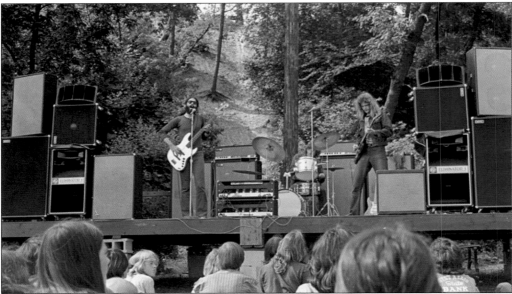

Ox was one of a number of popular local bands that performed at the Alternate Site, a green space on the lakefront. Bass player Jon Paris (left) later became a member of Dynamite Duck and then joined blues guitarist Johnny Winter's band. Guitarist Bob Metzger worked with Spencer Davis and Ian Matthews and began playing with Leonard Cohen in 1990. Ox opened for the Grateful Dead's first Milwaukee show in March 1971. (Photograph by Rich Zimmermann.)

Just three weeks before the legendary 1969 gathering at Woodstock, a three-day Midwest Rock Festival was held at Wisconsin State Fair Park in West Allis. The many after-market recordings available document the performances by Led Zeppelin and Blind Faith (with Stevie Winwood and Eric Clapton) among others. Although 41,000 tickets priced at $5, $6, and $7 were sold for the festival, 4,000 counterfeit tickets were used to gain entry. The emcee for the event was FM radio personality Bob Reitman. (Author's collection.)

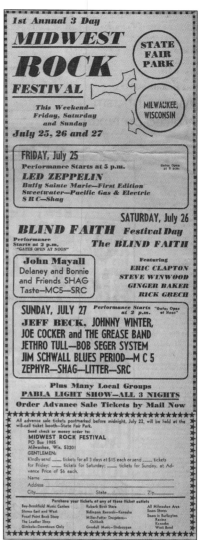

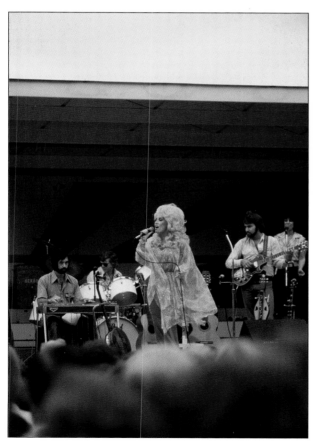

Dolly Parton performed "Milwaukee, Here I Come" and other favorite songs in an afternoon show at the Wisconsin State Fair grandstand in August 1977. During Parton's concert, radios all over the park were carrying the news that Elvis Presley had died earlier in the day. Parton previously appeared at the Auditorium in 1967 and Summerfest in 1969. Later shows included Summerfest in 1978 and 1987, Alpine Valley in 1979, and the Auditorium in 2005. (Photograph by author.)

I was there 1977/75
Evening

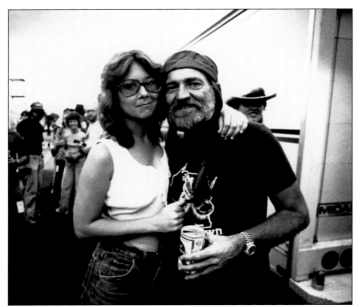

Judi Widen and Willie Nelson pose for the camera at the Wisconsin State Fair in August 1980. Nelson first gained fame as a songwriter, with "Funny How Time Slips Away," "Hello Walls," and "Crazy" becoming hit records for other artists. In the 1970s, Nelson's albums *Shotgun Willie* and *Red Headed Stranger* were at the top of the charts. Nelson first appeared at the Arena in 1970 and returned numerous times to play Summerfest, the Riverside Theater, Northern Lights Theater, and the Farm Aid concert at Miller Park. (Photograph by author.)

Summerfest 1977 1978 I was there ARENA 1983

Also state Fair 1979

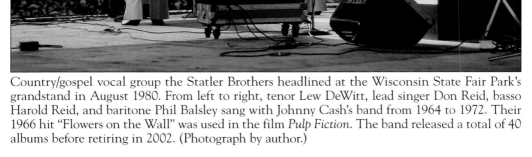

Country/gospel vocal group the Statler Brothers headlined at the Wisconsin State Fair Park's grandstand in August 1980. From left to right, tenor Lew DeWitt, lead singer Don Reid, basso Harold Reid, and baritone Phil Balsley sang with Johnny Cash's band from 1964 to 1972. Their 1966 hit "Flowers on the Wall" was used in the film *Pulp Fiction*. The band released a total of 40 albums before retiring in 2002. (Photograph by author.)

The popular 1980s band Culture Club concluded their 1998 nationwide reunion tour with an August 16 performance at the Wisconsin State Fair. The four original members, including front man Boy George, regrouped for the 15-city tour. (Photograph by Dennis Felber.)

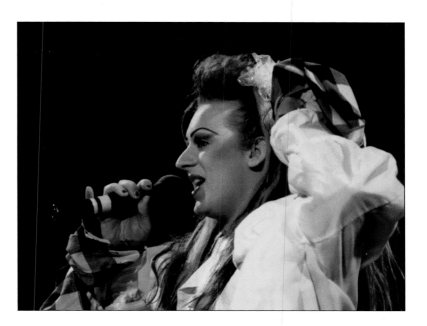

Summerfest is an annual event that has been held along Milwaukee's lakefront since 1968. More than 700 bands perform on 11 stages, attracting nearly one million people during the 11-day festival. The open-air Marcus Amphitheater and BMO Harris Pavilion also hold concerts independently of Summerfest, usually between May and October. (Photograph by author.)

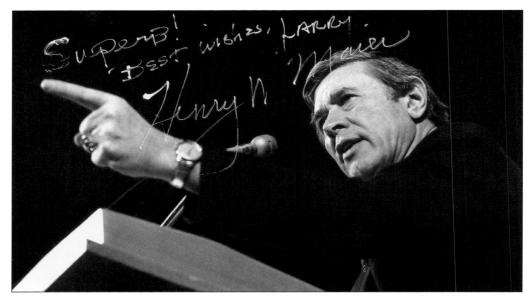

Henry Maier served as Milwaukee's mayor from 1960 to 1988. Violence from the 1967 urban riots forced the cancellation of events like a Monkees concert and a gospel show from singer Mahalia Jackson. That same year, Maier created an annual world music festival that quickly became known as Summerfest. He publicly chastised unruly crowd behavior at shows by Sly and the Family Stone in 1970, Humble Pie in 1973, and Black Sabbath in 1980. The Summerfest grounds are officially known as Henry Maier Festival Park. (Photograph by author.)

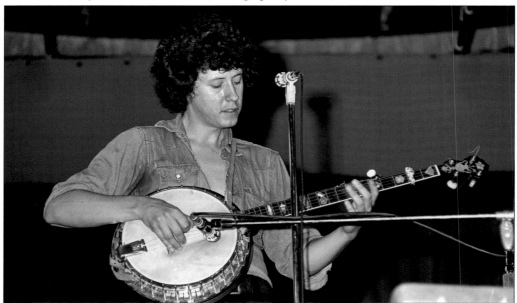

In 1972, Arlo Guthrie, at only 25 years old, was already a beloved counterculture figure with a performance at Woodstock and songs like "Alice's Restaurant Massacree" and "Coming into Los Angeles" to his credit. Guthrie's appearance at Summerfest included his latest hit single "City of New Orleans." Earlier in the evening, comedian George Carlin, who opened for Guthrie, was arrested by police on public obscenity charges. (Photograph by Rich Zimmermann.)

Summerfest 1977, 1980, 1983

Before they moved into radio-friendly material like "Centerfold" and "Love Stinks," the J. Geils Band was an excellent hard rock–influenced blues band that delivered powered-up versions of Smokey Robinson, John Lee Hooker, and Otis Rush songs in their concerts. Led by guitarist J. Geils (pictured) and vocalist Peter Wolf, the band made a number of Milwaukee appearances, including Summerfest in 1972. The J. Geils Band broke up in 1985 after disagreements over their musical direction. (Photograph by Rich Zimmermann.)

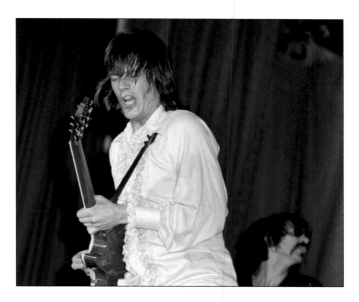

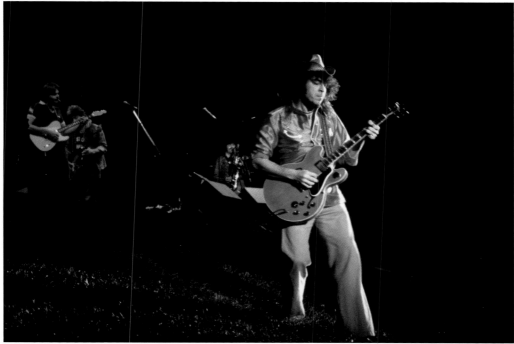

Guitarist Elvin Bishop had one big hit, and he played it during a show at the Summerfest main stage in 1977. Many in attendance came to hear "Fooled around and Fell in Love," but others clearly appreciated the rest of the set. In the 1960s, Bishop's guitar work as a member of the Paul Butterfield Blues Band helped propel that group to national prominence. When Bishop left to form his own band, his music took on country, jazz, and rock overtones in addition to the blues. (Photograph by Rich Zimmermann.)

Summerfest 1981 or '82

Journey opened Summerfest in 1980 with a main stage show attended by nearly 30,000 people. Lead singer Steve Perry walked off the stage and down the hill to be closer to the fans. The set list included "Dixie Highway," "Lights," and "Just the Same Way." (Photograph by Dennis Felber.)

There as bystander

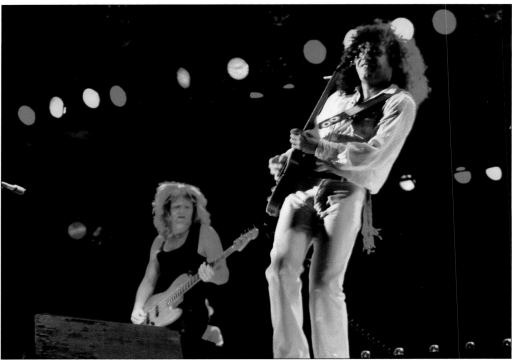

REO Speedwagon's Gary Richrath (right) and Bruce Hall are pictured on stage during the 1979 tour for *Nine Lives*. The band was signed to Epic Records in 1971 and spent five years relentlessly touring the Midwest. One of their first Milwaukee appearances was an October 4, 1972, show at Teddy's on Farwell Avenue. The band also played Hanna's around the same time. (Photograph by author.)

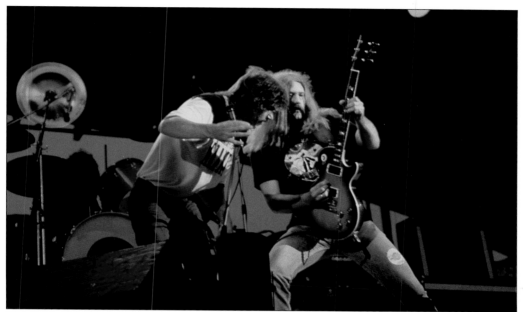

Danny Joe Brown (left) and Steve Holland of Molly Hatchet play to a crowd of 19,000 people at the Summerfest grounds on August 3, 1979. The Jacksonville, Florida–based band's bone-crunching Southern rock sound led to hits like "Flirtin' with Disaster." Brown died in 2005, and guitarist Duane Roland (pictured on the cover) died a year later. In a rather ironic twist of fate, Molly Hatchet was given a recording contract to fill the void in Southern rock music left by the 1977 plane crash that killed several members of Lynyrd Skynyrd. (Photograph by author.)

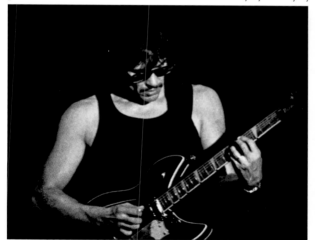

Steppenwolf enjoyed worldwide success between 1968 and 1972, producing top-10 singles "Born to Be Wild," "Magic Carpet Ride," and "Rock Me." During that time period, the group played the Scene and the Milwaukee Arena. Today, singer John Kay, seen at left, is the only original member in the band and makes frequent appearances at Summerfest. Pictured at right is Kansas vocalist Steve Walsh at Summerfest in 1986. Kansas was one of the biggest bands of the mid-1970s, releasing best-selling albums like *Leftoverture* and *Point of Know Return*. The Power Tour in 1986 was the first of several reunions with former band members that left over the years. (Photographs by Jeff Dobbs.)

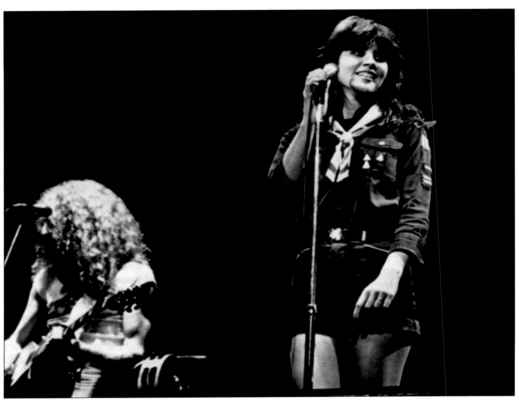

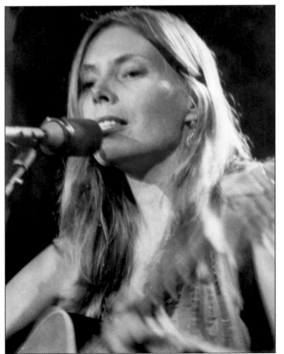

Alpine Valley, a music amphitheater with the capacity to hold 37,000 people, opened near East Troy, Wisconsin, in 1977. Because the venue draws audiences from Milwaukee, Chicago, Rockford, and Madison, bands often forego a Milwaukee or Chicago engagement to play here. The inaugural season offered no controversial acts, with Bob Seger and Kansas being the heaviest bands on the schedule. Linda Ronstadt (pictured) and her band brought a softer, country-rock sound to the stage. (Photograph by Al Gartzke.)

Summer/1st 1970s

Folksinger Joni Mitchell performed at Alpine Valley in August 1979. The audience numbered just over 7,000 people. Her band included stellar musicians Pat Metheny on guitar, Jaco Pastorius on bass, and Michael Brecker on horns. (Courtesy of Bobbin Beam.)

MADISON 1975

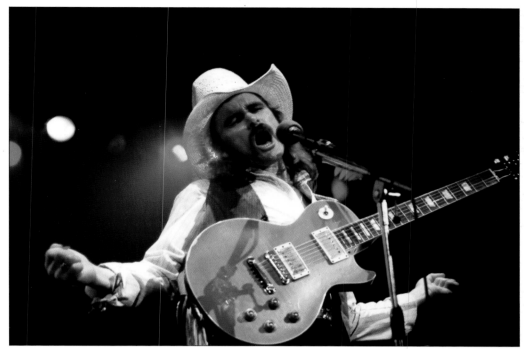

Allman Brothers Band guitarist Dickey Betts (pictured) and Gregg Allman spent the mid-1970s locked in a bitter struggle over money and the direction of the band's music that was fueled by cocaine and alcohol. They were able to put their differences aside in 1979 for a new album, *Enlightened Rogues*, and a summer tour that included a stop at Alpine Valley. (Photograph by author.)

Tom Petty's show for 12,500 fans at Alpine Valley in August 1981 was an indication of how popular he had become since his 1979 Milwaukee appearance. Just 18 months earlier, Petty drew 1,800 people to the Uptown Theater. With his band, the Heartbreakers, Petty has played Summerfest 13 times in addition to return engagements at Alpine Valley. (Photograph by Dave Gilo.)

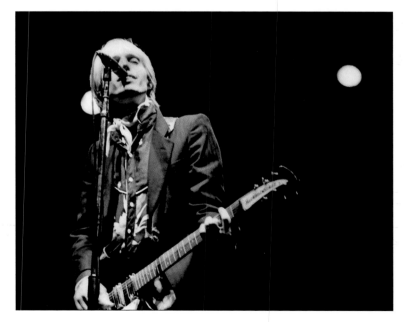

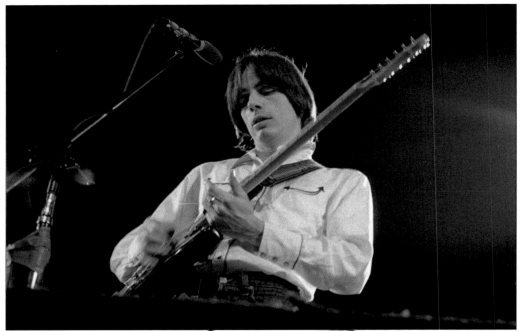

Jackson Browne's performance at Summerfest's Main Stage in 1978 included "The Fuse," "Fountain of Sorrow," and "Running on Empty" as part of a 25-song set list. Browne was accompanied by David Lindley (lap steel guitar, violin, vocals), Karla Bonoff and Rosemary Butler (vocals), Russ Kunkel (drums), Leland Sklar (bass), Craig Doerge (keyboards), Danny Kortchmar (guitars), and Doug Haywood (guitars, vocals). (Photograph by Rich Zimmermann.) · SAW 1980

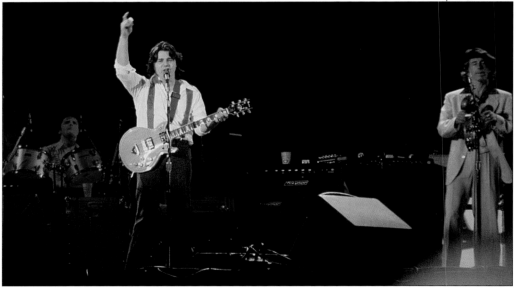

Guitarist Steve Miller was born in Milwaukee in 1943. After attending the University of Wisconsin–Madison, Miller headed to San Francisco and found success in the burgeoning West Coast blues scene. Miller's many Milwaukee shows included performances at Hanna's, Summerfest, and Alpine Valley. (Photograph by Tim Townsend.)

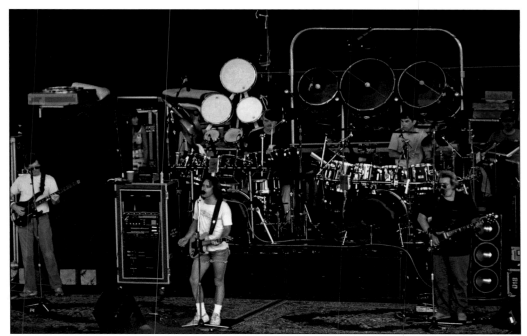

Phil Lesh (left), Bob Weir, and Jerry Garcia are pictured at the Grateful Dead's Alpine Valley show on June 20, 1988. The band previously performed at Alpine in 1982, 1984, 1986, and 1987. The Dead's first Milwaukee appearance was in March 1971 at the Red Carpet Expo Center across from the airport. Other shows included the Performing Arts Center in October 1972, the Auditorium in February 1978 and May 1980, and the Arena in April 1989. They were scheduled to play Summerfest in 1978, but a rainstorm prevented the show from taking place. Founding member Jerry Garcia died in 1995. (Photograph by Jeff Dobbs.)

Jake Hess (left) and Joe Widen are backstage with Joan Jett prior to her show at the Waukesha County Fair in July 2005. Hess and Widen are local musicians with metal band Ahab's Ghost. (Photograph by author.)

SUMMERFEST PERFORMERS

Summerfest performers have included:

1968 The Robbs and the Messengers

1969 B.B. King, Ramsey Lewis, Wilson Pickett, and the Staple Singers

1970 James Brown, Mountain, Procol Harum, Bobby Sherman, and Sly & the Family Stone

1971 The Association, Judy Collins, Jose Feliciano, Woody Herman, the Jackson 5, George Pritchett, Siegel-Schwall Band, and Muddy Waters

1972 Bread, Glen Campbell, David Cassidy, Ray Charles, the Doors, Aretha Franklin, the J. Geils Band, Arlo Guthrie, Quicksilver Messenger Service, and Edgar Winter

1973 Blood, Sweat & Tears, Sammy Davis Jr., the Doobie Brothers, Duke Ellington, Isaac Hayes, Humble Pie and the Blackberries, and Loretta Lynn

1974 Johnny Cash, Melanie, Helen Reddy, and Short Stuff

1975 Joan Baez, Ella Fitzgerald, Gordon Lightfoot, and James Taylor

1976 The Band, Tony Bennett, Willie Dixon, Waylon Jennings, the Ohio Players, and War

1977 America, James Cotton, Hall & Oates, John Lee Hooker, Willie Nelson, Pete Seeger, and Hank Williams Jr.

1978 Jackson Browne and Emmylou Harris

1979 Bad Company, Elvin Bishop, Pure Prairie League, Jerry Reed, and Sam & Dave

1980 The Atlanta Rhythm Section, Count Basie, Judas Priest, Albert King, Kenny Loggins, and Rick Nelson

1981 The Allman Brothers Band; the 5th Dimension; Iron Maiden; Jan and Dean; Peter, Paul and Mary; Billy Squier; and George Thorogood and the Destroyers

1982 The Bar-Kays; Crosby, Stills, Nash & Young; the Charlie Daniels Band; the Mamas & the Papas; Johnny Mathis; the Joe Perry Project; the Romantics; and Santana

1983 The Dickey Betts Band, Albert Collins, Kool & the Gang, R.E.M., Johnny Rivers, Tina Turner, and Stevie Ray Vaughan

1984 The Blasters, John Denver, the Everly Brothers, the Go-Go's, Al Jarreau, Huey Lewis and the News, the Moody Blues, Roy Orbison, the Temptations, and the Violent Femmes

1985 Bon Jovi, Bryan Adams, the Fabulous Thunderbirds, Kris Kristofferson, John Mayall and the Bluesbreakers, the Oak Ridge Boys, and the Pointer Sisters

1986 Belinda Carlisle, Eric Clapton, Gang of Four, Patti LaBelle, Los Lobos, Magic Slim & the Teardrops, the Marshall Tucker Band, the Neville Brothers, Bonnie Raitt, Three Dog Night, and UFO

1987 The Beach Boys, Cheap Trick, Chicago, Duran Duran, Whitney Houston, Dolly Parton, Johnny Rivers, Linda Ronstadt, Run DMC, and Paul Simon

1988 The BoDeans, Jimmy Buffet, Natalie Cole, Heart, K.D. Lang, Sting, Robin Trower, and Stevie Wonder

1989 Paula Abdul, Jimmy Cliff, Bob Dylan, Joan Jett, Rod Stewart, Randy Travis, and Johnny Winter.

Five

"BORN UNDER
A BAD SIGN"

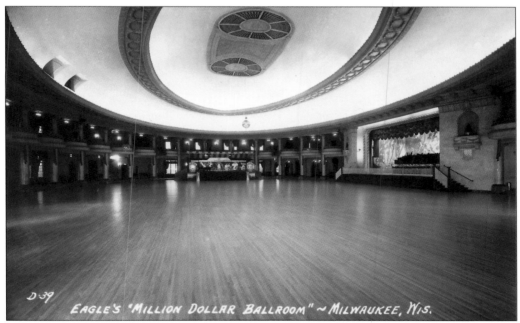

EAGLE'S "MILLION DOLLAR BALLROOM" ~ MILWAUKEE, WIS.

Milwaukee impresario George Devine opened the Million Dollar Ballroom in 1934. He was one of the first showmen in Milwaukee to book rock and roll bands at his hall. It was here that Buddy Holly, Richie Valens, and the Big Bopper began the Winter Dance Party in January 1959. Eleven days later, their plane crashed after a show at the Surf Ballroom in Clear Lake, Iowa. Devine's ballroom is now known as the Rave. (Author's collection.)

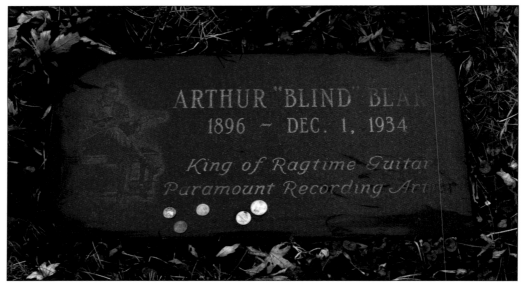

Legendary blues guitarist Arthur "Blind" Blake disappeared after making a number of records in Grafton in 1931. In 2012, a death certificate from the courthouse showed that Blake died in Milwaukee in 1934 and was buried in an unmarked grave at Glen Oak Cemetery on Green Bay Road. The following year, a stone was placed, commemorated Blake's final resting place after nearly 80 years of obscurity. (Photograph by author.)

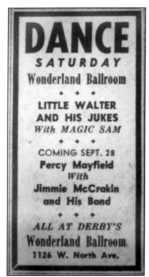

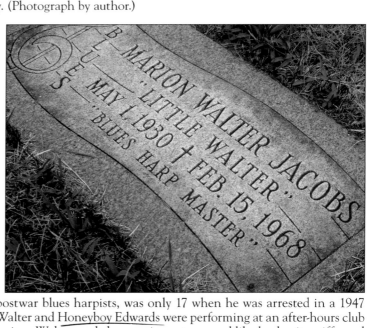

Little Walter, king of the postwar blues harpists, was only 17 when he was arrested in a 1947 Milwaukee nightclub raid. Walter and Honeyboy Edwards were performing at an after-hours club when police cleared the premises. Walter made harmonica notes sound like lead guitar riffs, and Muddy Waters, Bo Diddley, and Jimmy Rogers were quick to get Walter's sound on recordings of their own. His Milwaukee appearances included a show with Magic Sam at Wonderland and another with Howlin' Wolf at the Million Dollar Ballroom. He died in Chicago after a fight outside a nightclub in 1968. He was 38 years old. (At left, author's collection; at right, photograph by author.)

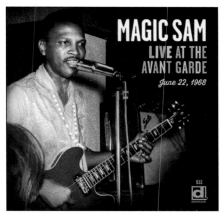

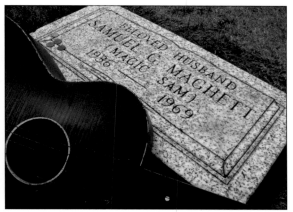

Samuel Maghett was born in Mississippi in 1937. After hearing records by Muddy Waters and Little Walter, he was inspired to learn to play the guitar. Maghett moved to Chicago and won a contract with Cobra Records at age 19. As Magic Sam, he began Chicago's West Side Sound movement alongside Buddy Guy and Otis Rush. Magic Sam's 1968 performance at the Avant Garde was released on compact disc in 2013. He died of a heart attack in 1969 at age 32. Magic Sam is buried near Muddy Waters in Chicago's Restvale Cemetery. (At left, courtesy of Delmark Records; at right, photograph by author.)

In July 1972, comedian George Carlin was arrested for public obscenity while performing at Summerfest. It was his recital of "Seven Words You Can Never Say on Television" that caused police to stop the show. Carlin went on to have a long and prosperous career, probably helped immensely by the publicity from Milwaukee. (Photographs by Rich Zimmermann.)

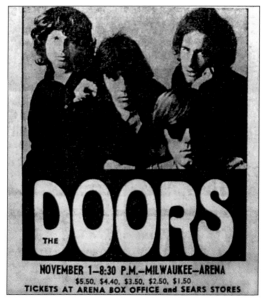

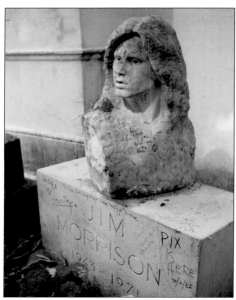

The Doors played Milwaukee only once, appearing at the Arena in November 1968. The Doors' creative period ended in 1971 when vocalist Jim Morrison died in Paris; however, the group's popularity never waned, and their albums have sold more than 100 million units worldwide. Depending on who one talks to, Morrison is considered a brilliant American poet or the ultimate 1960s crackpot. He is buried in the Poets Corner section of Père Lachaise Cemetery in Paris. The 280-pound granite bust was stolen in 1988. (Photographs by author.)

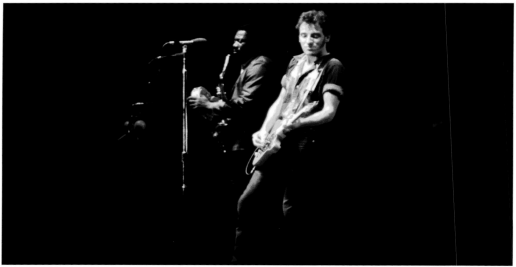

Bruce Springsteen and the E Street Band's first concert in Milwaukee was interrupted about eight songs into the show. Police evacuated the Uptown Theater because somebody called in a bomb threat. It took more than an hour to search the theater, and the band waited in a bar across the street. After a decade of playing in obscurity, Bruce Springsteen broke out in 1975 with the immensely popular album *Born to Run*. By 1978, his epic three-hour shows were selling out arenas around the world. Along with the fabulous E Street Band, Springsteen came to Milwaukee twice in 1978 (June 9 and November 27) during the Darkness on the Edge of Town Tour. (Photograph by author.)

1975

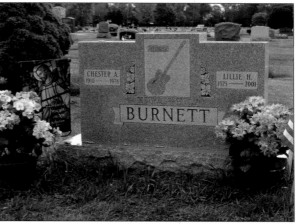

The legendary Howlin' Wolf was born Chester Arthur Burnett in 1910 near West Point, Mississippi. He learned to play the guitar from Charley Patton and named Blind Lemon Jefferson and Blind Blake among his other musical idols. When he moved to Chicago, Wolf met guitarist Hubert Sumlin, who provided the hypnotic riffs on classics such as "Smokestack Lightning" and "Killing Floor." Howlin' Wolf's Milwaukee appearances include Devine's Million Dollar Ballroom in 1965, a blues festival at Wisconsin State Fair Park in 1973, and a show at Teddy's on Thanksgiving Day in 1974. (Photographs by author.)

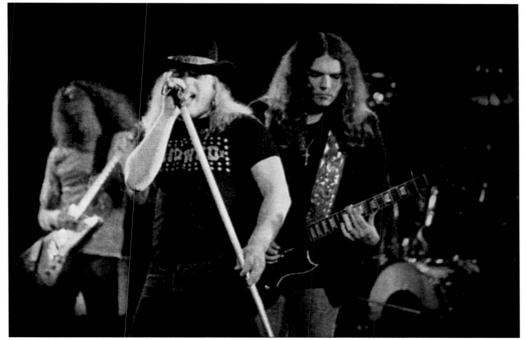

Lynyrd Skynyrd vocalist Ronnie Van Zant is flanked by guitarists Allen Collins (left) and Gary Rossington while headlining a December 5, 1976, show at the Arena. After a 1977 plane crash killed Van Zant, guitarist Steve Gaines, and singer Cassie Gaines, the surviving band members regrouped as the Rossington-Collins Band. Troubles continued, however, as drummer Artimus Pyle shattered his leg in a motorcycle accident. Allen Collins died in 1990, bassist Leon Wilkeson followed in 2001, and pianist Billy Powell passed away in 2009. (Photograph by author.)

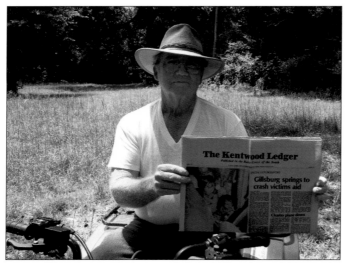

John Bond's farm in McComb, Mississippi, adjoins the woods where the private plane carrying members of Lynyrd Skynyrd crashed in August 1977. Bond was one of the first responders on the scene that summer night. He and his neighbors pulled people from the wreckage and transported them in pickup trucks to a hospital 10 miles away. In 2005, Bond revisited the crash site and pointed to aluminum fragments from the plane still strewn over an area larger than a city block. (Photograph by author.)

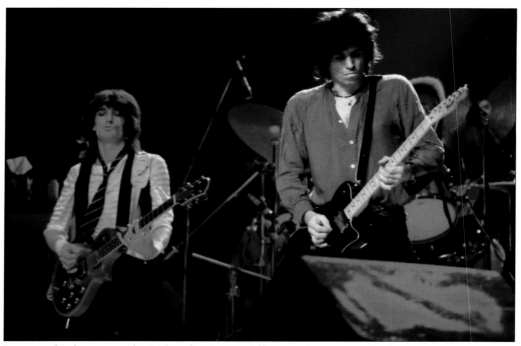

Lawsuits for damage to the Milwaukee Arena following this concert by the New Barbarians (see page 40 for more) were settled when a judge ruled that revenue from a "make-good" date would be used to pay for repairs. Rolling Stones guitarist Ron Wood (left) subsequently performed a two-and-a-half-hour show at the Uptown Theater in January 1980. The band included Ian McLagan (keyboards), Bobby Keys (sax), Johnnie Lee Schell (guitar), Reggie McBride (bass), Andy Newmark (drums), and Mackenzie Philips (background vocals). Keith Richards (right) did not appear. (Photograph by author.)

Milwaukee's morning newspaper, the *Milwaukee Sentinel*, carried the news of John Lennon's death in the early edition on December 9, 1980. Lennon was only 40 years old when he was gunned down in front of the Dakota apartment building by a mentally unbalanced fan. Nick Topping, the Milwaukee promoter who brought the Beatles here in 1964, spent some time with John after the show. He remembered John as looking for acceptance and love, tender, and ornery at the same time. Nick thought Lennon was, at 24, "the oldest young man I'd ever met." (Photograph by author.)

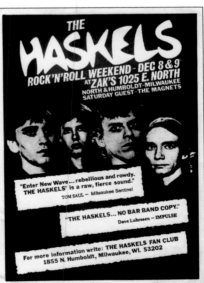

The Haskels was made up of, from left to right, Richard LaValliere, Guy Hoffman, Jerome Brish, and Jerry LaVallierre. They are seen in a promotional flyer for a concert at Zak's. An earlier version of the band included Jill Kossoris and Scott Krueger, who left to form the Shivvers. LaValliere joined the Oil Tasters and then moved to New York and started the band Polkafinger. He died in February 2012. Hoffman went on to become the drummer for the BoDeans and then the Violent Femmes. Brish died after being attacked and beaten on Humboldt Avenue in May 1991. (Photograph by author, courtesy of Guy Hoffman and milwaukeerockposters.com.)

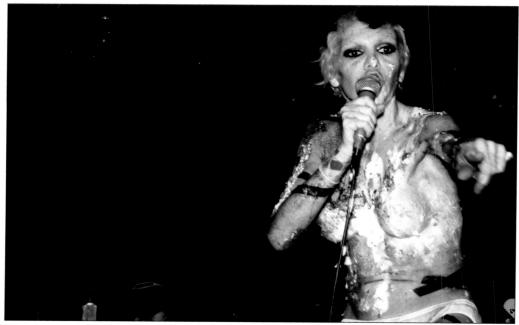

The Plasmatics brought their gimmick-fueled rock show to the Palms on January 18, 1981. During the performance, singer Wendy O. Williams smashed some televisions and cut a guitar in half with a chainsaw. A scuffle broke out when several Milwaukee police officers arrested Williams in the alley behind the club. The singer's face was cut and required a dozen stitches. She filed assault and battery charges against the city in a case that was eventually dismissed in 1984. (Photograph by author.)

Stevie Ray Vaughan dies in crash at Alpine
Blues guitarist, 4 others killed when copter falls

Texas blues guitarist Stevie Ray Vaughan lost his life in a helicopter crash following a 1990 show at Alpine Valley. Vaughan's band, Double Trouble, opened for Eric Clapton. The concert ended with a jam session that included Vaughan, Clapton, Robert Cray, Buddy Guy, and Jimmie Vaughan performing "Sweet Home Chicago." Vaughan's previous area appearances included Summerfest in 1984 and 1986, the Oriental Theatre in 1985, and Wisconsin State Fair Park in 1987. He is buried at Laurel Land Cemetery in Dallas, Texas. (Author's collection.)